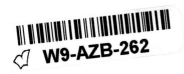
The SIERRA CLUB Guide to
Close-up Photography in Nature

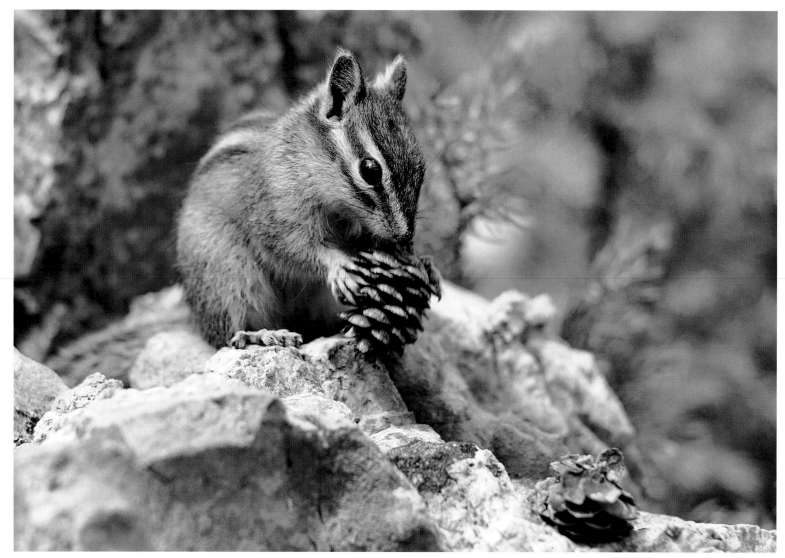
Chipmunk

The SIERRA CLUB Guide to
Close-up Photography in Nature

Text and Photographs by
Tim Fitzharris

Sierra Club Books San Francisco

LIBRARY OF CONGRESS CATALOGING-IN-PUBLICATION DATA

Fitzharris, Tim, 1948—
 The Sierra Club guide to close-up photography in nature / Tim Fitzharris
 p. cm.
 Includes bibliographical references.
 ISBN 0-87156-913-2 (pbk. : alk. paper)
1. Nature photography — Handbooks, manuals, etc. 2. Photography,
Close-up—Handbooks, manuals, etc.
I. Sierra Club. II. Title.
TR721.F59 1998 97-33675
778.9'3—dc21 CIP

Production Coordinator: Joy Sambilad Fitzharris
Design: Klaus van Tyne

Printed and bound in Hong Kong

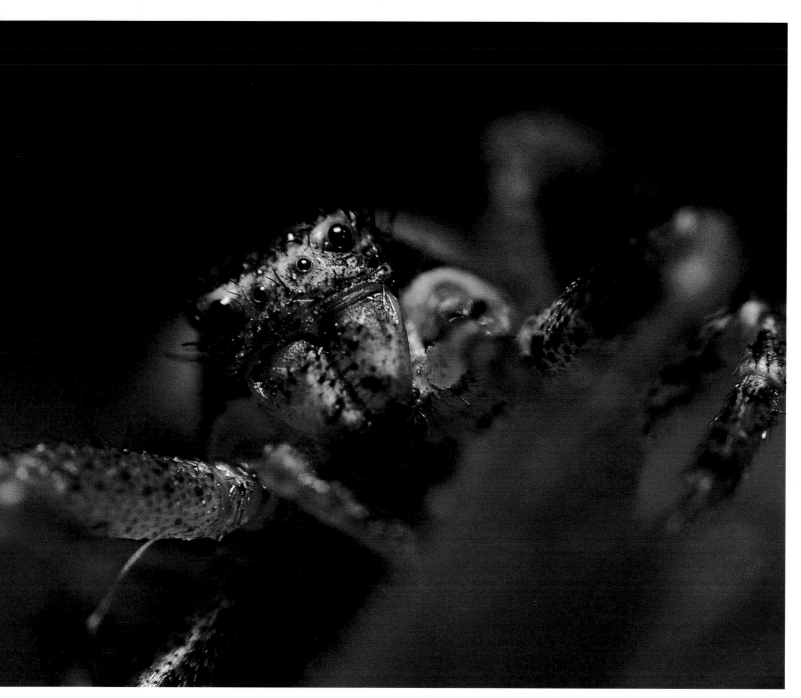

Jumping Spider

For Jesse

Other Books by Tim Fitzharris

Nature Photography Hotspots

Wild Bird Photography: National Audubon Society Guide

Nature Photography: National Audubon Society Guide

The Sierra Club Guide to 35 mm Landscape Photography (New Edition)

Fields of Dreams: Travels in the Wildflower Meadows of America

Soaring with Ravens: Visions of the Native American Landscape

Coastal Wildlife of British Columbia (written by Bruce Obee)

Wild Wings: An Introduction to Birdwatching

Forest: A National Audubon Society Book

Wild Birds of Canada

Canada: A Natural History (with writer John Livingston)

British Columbia Wild

Wildflowers of Canada (with writer Audrey Fraggalosch)

The Wild Prairie: A Natural History of the Western Plains

The Adventure of Nature Photography

The Island: A Natural History of Vancouver Island

Painted Lady Butterfly on Sunflower

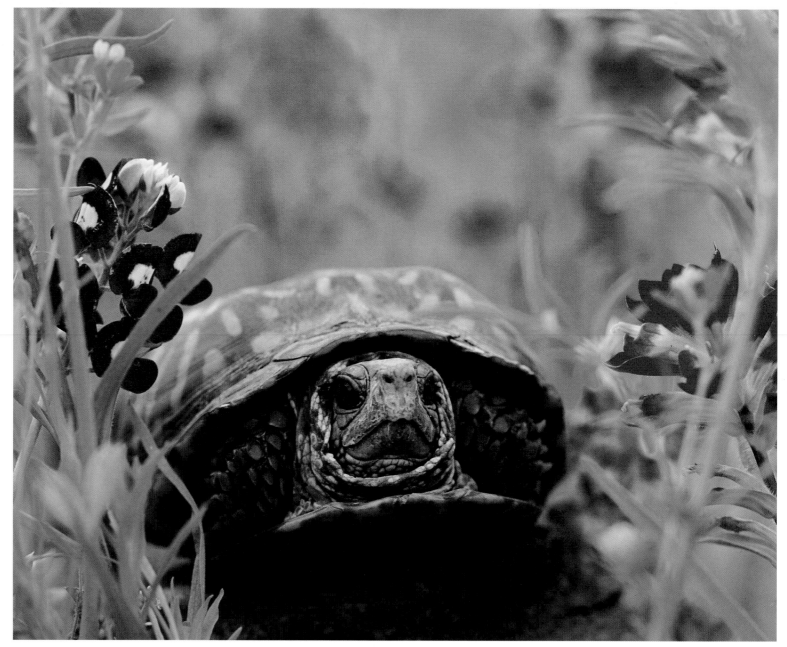

Box Turtle

Table of Contents

Nature's Studio

THE TINY FROGS were all around me, yet I could not find even one. I turned off the flashlight and moved cautiously into the darkness and deeper water. The swamp's bottom, partially glazed with left-over winter ice, was hard and slippery in some places, sucking muck in others. Half-submerged deadfalls added to the precarious footing. The atmosphere was saturated with the sound of my quarry—spring peepers. The steady, electronic jingle of their mating chorus was mesmerizing and soon, just as the night had left me blind, the frogs' song stole my hearing.

Handicapped in this way, I soon stumbled, gasping as murky water poured into my chest waders. With one hand holding the camera out of the soup, I struggled upright and switched on the flashlight to regain my bearings, waiting for my body to take the icy edge off the water that sloshed inside my waders.

The commotion had momentarily silenced the peepers. The flashlight's yellow beam played weakly over the cattails as my eyes groped for one of the camouflaged

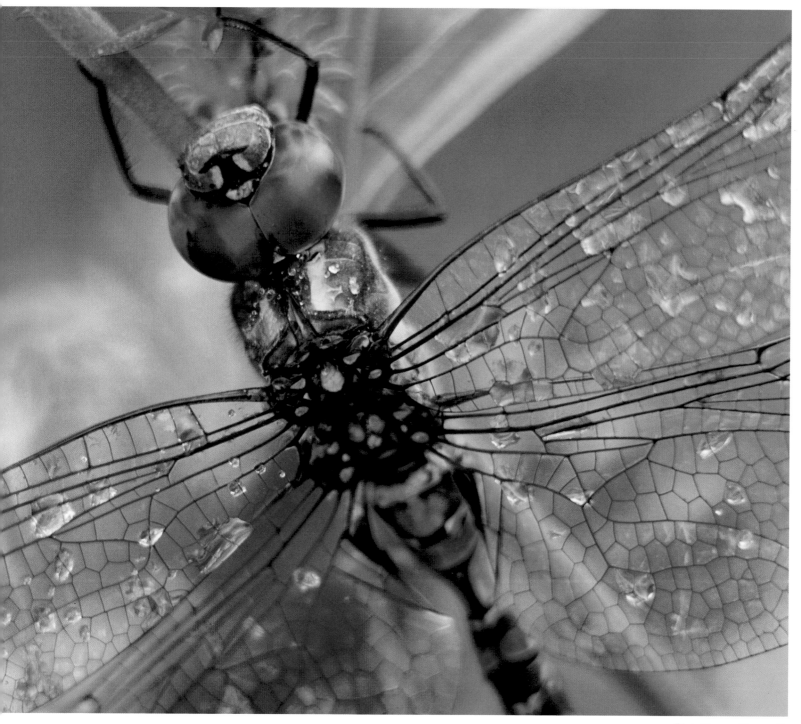

Blue Darner Dragonfly

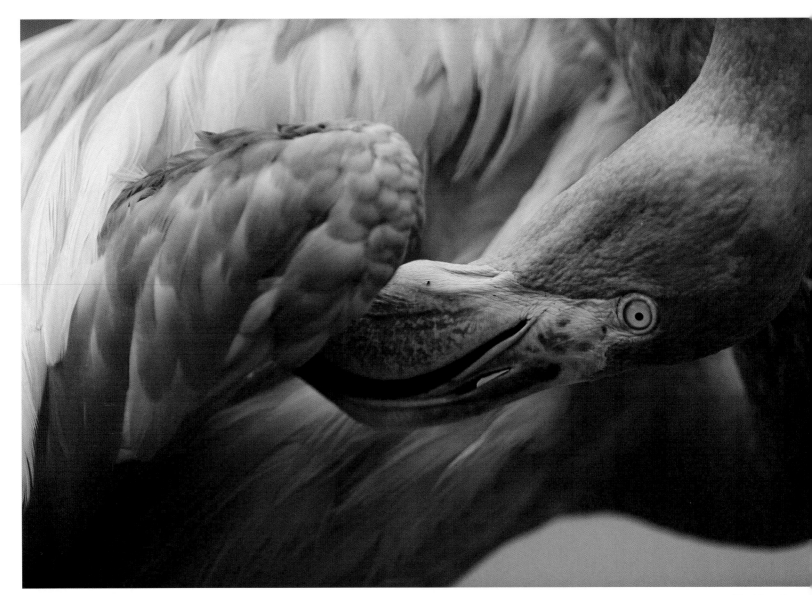

Caribbean Flamingo Preening

Red Fox (oppo

amphibians. The peeping started some distance away but was quickly drowned by a single voice that began to reverberate all around me. At length, I spotted the frog right beside my boot, sitting just above the water on a cattail stem. A small, glistening jewel, it was about the size of the end of a finger. As it sang, its translucent throat pouch bubbled out, showing a thin network of veins stretched over its surface. Excitedly, I got the camera ready.

Unlike the photographs that resulted from this experience (see page 103), the close-up images that you see of frogs and other small creatures are often made under controlled studio conditions indoors—usually with excellent results. There are fine guidebooks available to show you how to do this (see the appendix). This volume deals primarily with how to photograph plants and animals by existing light amidst the beauty of the natural environment. The text is aimed at those who understand basic photographic principles and who have experience shooting nature subjects. Current techniques of close-up photography based on the use of modern auto-focus, auto-exposure, dedicated TTL-flash cameras are explained.

Also provided is introductory information on computer imaging, a technique which replaces conventional darkroom procedures such as dodg-

ing, burning, and color correction. In addition, computer imaging allows you to produce an unlimited variety of special effects and create seamlessly realistic images or abstract montages based on elements in the natural world.

It will not be as easy for you to photograph

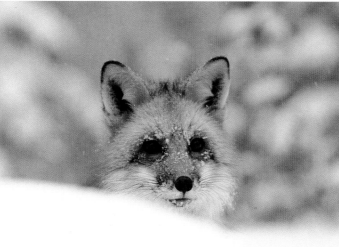

frogs today as it was for me to shoot the spring peepers 20 years ago. In North America most of the frog's habitat of swamps and marshes has been drained and replaced by cities, suburban sprawl, and industrial and agricultural development. A sinister decline of frog populations, even in protected areas, is being charted by scientists worldwide. Frogs, of course, aren't the only small critters that are losing their battle for survival.

The spring woods are not yet silent but they are headed in that direction. Due to habitat destruction, forest fragmentation, and pesticide use, song bird numbers have declined 50% in the last two decades. Never to be seen again over the prairies and foothills of Texas, Colorado, or Alberta are the 400,000 migratory Swainson's hawks killed in their winter home in Argentina by pesticides in part developed and marketed by American chemical companies with the aid of the U.S. government. Such examples abound.

These declines in wildlife populations will persist as long as we permit politicians to measure human success in terms of their shortsighted, self-serving policies of relentless economic growth, ever increasing GNP, and a refusal to deal with the basic issue of human overpopulation; as long as we allow their greedy patrons, big industry and its perverted stepson, big media, to seduce us and inoculate our children with the empty ideals of materialism. Unless this self-destructive agenda can be rewritten, it seems more than likely that the quality of our lives will continue to deteriorate while frogs, song birds, and other creatures are added to the list of endangered and extinct species.

Terms and Tools

Terms and Tools

BEFORE DISCUSSING equipment, it is necessary to explain the specialized termi-
nology that is used in the practice of close-up photography.

WHAT IS CLOSE-UP PHOTOGRAPHY?

When you record the subject larger than is possible with the camera's prime lens,
you are doing close-up photography. Standard, fixed focal-length lenses, adjusted to
their closest focusing distance, allow you to make frame-filling photographs of sub-
jects about the size of a loaf of bread (8" x 12"). For greater magnifications, you must
use special close-up (macro) lenses or attach close-up accessories to prime lenses to
allow them to focus closer than normal. Macro-photography (photomacrography) is
close-up photography at magnifications greater than life-size. Micro-photography
(photomicrography) is close-up photography through a microscope.

MAGNIFICATION AND REPRODUCTION RATIO

Numerical terms express the degree of magnification of the subject related to the
in-camera film. A magnification, or reproduction ratio, of 1:8 means that the subject is

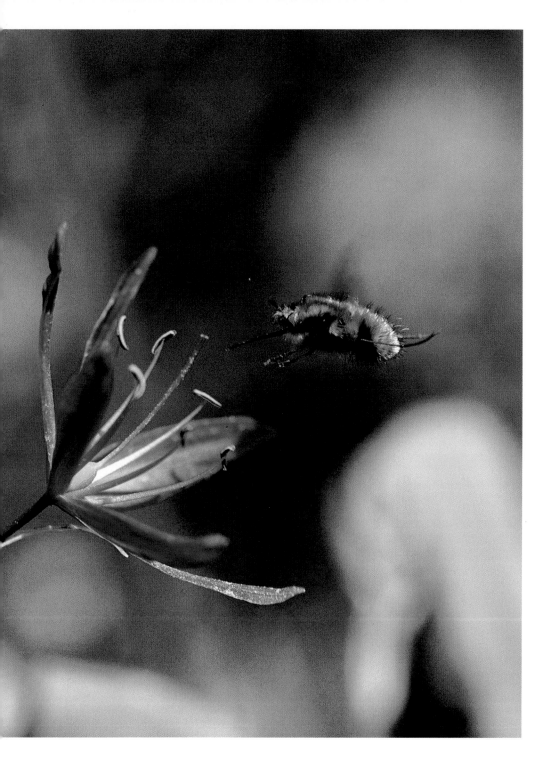

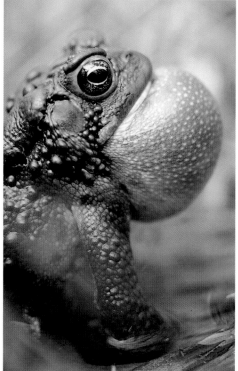

Trilling American Toad. *During the mating season, toads are nearly oblivious to the close approach of a photographer. I laid down beside this specimen and shot him from less than a foot away. Canon T90, 100 mm Canon macro lens, Kodachrome 64, 1/125 second at f/8.*

Hovering Bee Fly. *The greater the magnification of the subject, the more carefully you must focus. Fortunately, bee flies hover almost motionless for seconds at a time, making them one of the easier insects to capture in flight. Canon T90, 300 mm L Canon lens, 50 mm extension tube, Kodachrome 64, 1/250 second at f/5.6.*

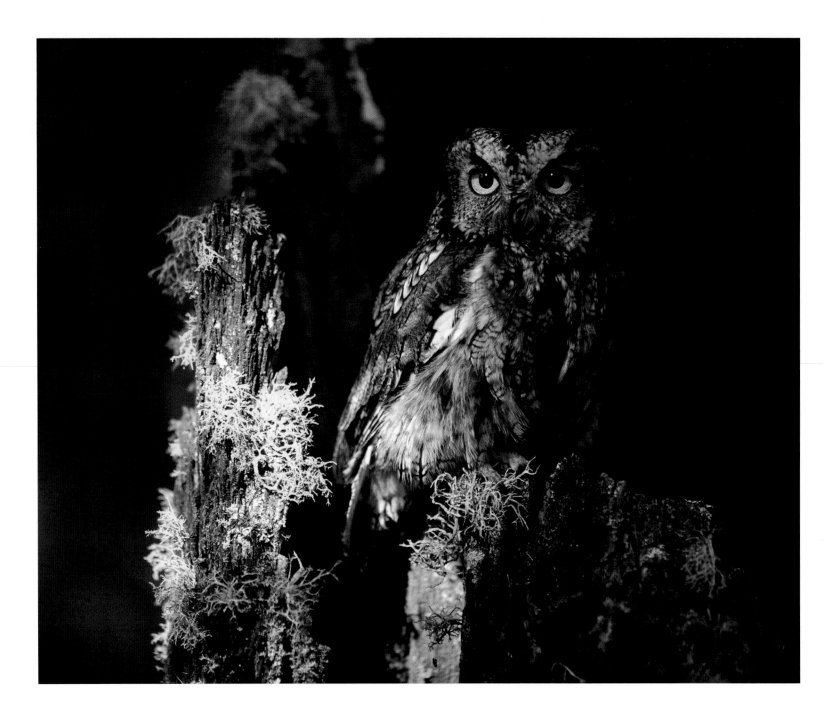

eight times larger than the film frame on which it is recorded. A reproduction ratio of 1:1 means that the subject is the *same size* as the film frame (life-size). A ratio of 2:1 (twice life-size) means that the subject is only *half as large* as its image on film.

Presentation Magnification

The actual size of the image presented for viewing (the presentation magnification) is unrelated to the practice of close-up photography. Even though a highway billboard or projection screen may show the subject greater than life-size, it does not necessarily follow that close-up techniques were used to make the image.

Working Distance

In wildlife photography the camera-to-subject distance (working distance) is an important consideration dependant on lens focal length and the desired degree of magnification. The working distance for a timid butterfly is greater than for a confident bumblebee and requires different equipment.

Field-of-View

The expanse of the rectangular in-focus area framed by the camera and visible in the viewfinder is called the field-of-view. Knowing the size of the field-of-view makes it possible to estimate the degree of magnification of the subject. This allows you to select the appropriate

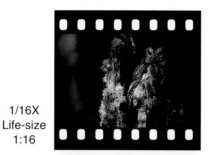

1/16X
Life-size
1:16

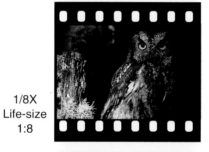

1/8X
Life-size
1:8

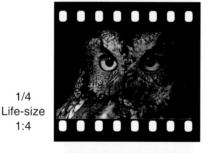

1/4
Life-size
1:4

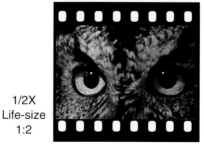

1/2X
Life-size
1:2

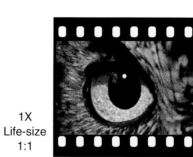

1X
Life-size
1:1

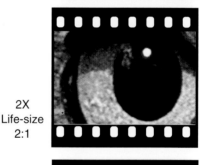

2X
Life-size
2:1

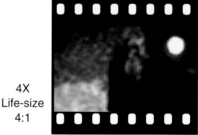

4X
Life-size
4:1

***MAGNIFICATION / REPRODUCTION RATIOS.** It is easy to estimate reproduction ratios if you compare your subject to the actual size of a 35 mm film frame, which also happens to be about the size of your thumb and fore-finger when joined. The full-page reproduction of the screech owl is the presentation magnification and is unrelated to close-up technique.*

Frozen Maple Leaves. The shallow depth-of-field required for recording leaves or other inanimate objects on the forest floor makes for easy close-up photography. Keep the film plane parallel to the subject to insure that all picture elements fall within the depth-of-field zone and give special attention to the composition. Canon T90, 135 mm Komura lens, 25 mm extension tube, Fujichrome Velvia, 1/15 second at f/8.

Cattails. Shallow depth-of-field allowed me to blur the background in this photo, accentuating the main subject. Canon T90, 80-200 mm Canon lens, 25 mm extension tube, Fujichrome 50, 1/60 second at f/5.6

Garden Spider. Electronic flash and extension bellows were used to attain frame-filling magnification for this small subject recorded at about 2:1. Canon EOS A2, 50 mm lens, extension bellows, Fujichrome Velvia, 1/125 second at f/16.

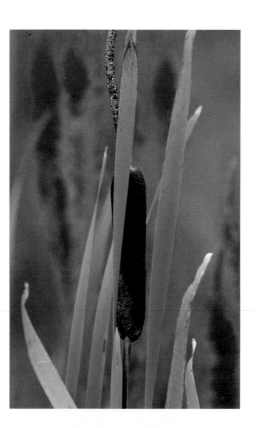

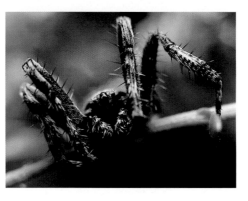

camera/lens set-up for shooting. The dimensions of the 35 mm film frame are about 1" x 1.5". If your field-of-view (usually a little larger than the subject) is also 1" x 1.5", then the reproduction ratio is 1:1 (life-size). If your subject measures 2" x 3" across (e.g., a leopard frog), the magnification is 1:2 (one-half life-size). A crab spider would take up a field-of-view 1/2" x 3/4", so a frame-filling image of it requires a magnification of 2:1 (twice life-size).

Thumb-and-Forefinger Estimates

By joining your thumb and forefinger to make a rectangular shape, you enclose an area about the size of a section of 35 mm film. I use this crude but convenient measuring device to help determine reproduction ratios. If my subject fits comfortably inside, then I need to set up my equipment for life-size reproduction. If two of the subjects fit inside nose-to-tail, then I need to set up for twice life-size (2:1) reproduction. If my fingers frame but half of the subject, then magnification is one-half life-size (1:2).

Depth-of-Field Zone

The near/far dimension of the image that is rendered sharply is called the depth-of-field zone. This zone decreases as magnification and aperture size increase, which creates special problems in close-up photography. Ways of overcoming this technical difficulty are discussed in the next chapter.

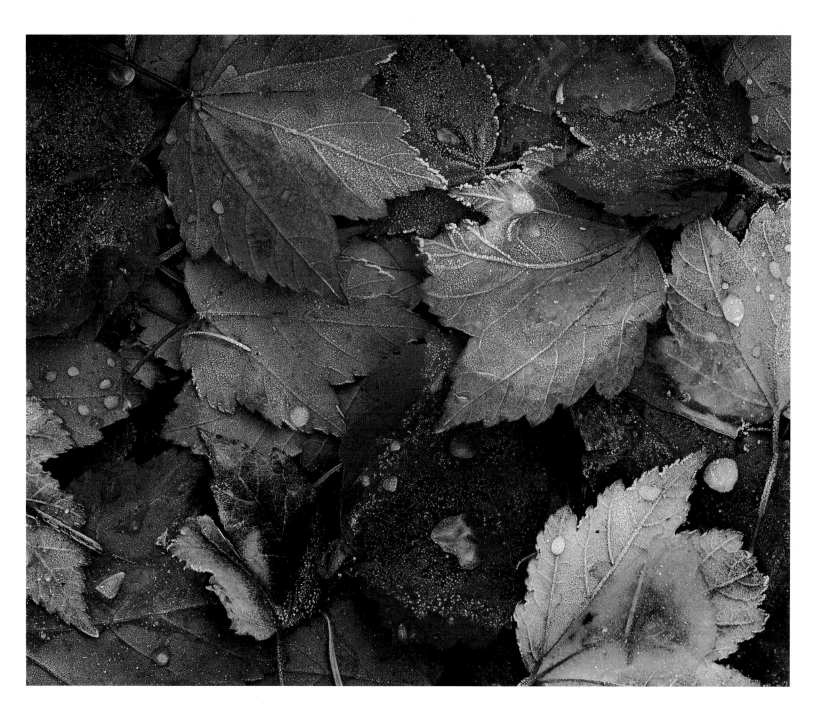

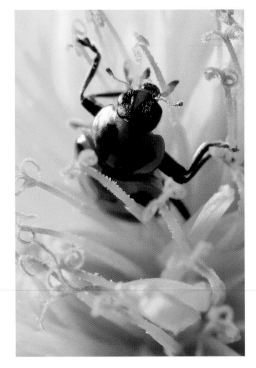

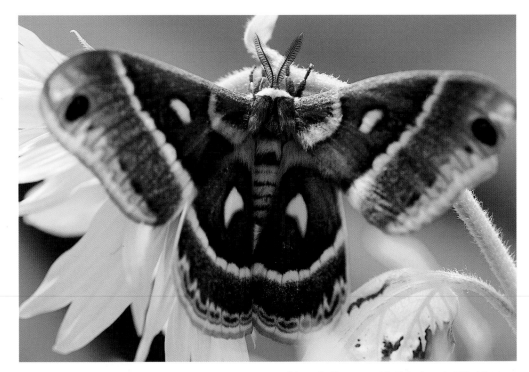

Ladybug on Dandelion. *This tiny insect was photographed as it emerged from the packed petals of a dandelion head. I used a hand-held 35 mm camera with two small flash units attached. The brief duration of the flash (1/1000 second) ensured a sharp picture despite considerable camera shake. Canon T90, 50 mm Canon lens, extension bellows, Kodachrome 64, 1/90 second (flash sync speed) at f/16.*

Cecropia Moth. *A standard macro-zoom lens was adequate to record this giant specimen. The soft light from an overcast sky produced saturated color, but the weakness of the illumination forced me to use a large aperture. This limited the depth-of-field, evident in the out-of-focus wing tips. Canon EOS A2, 28-105 mm Canon lens (with macro focusing), Ektachrome EPP 100, 1/30 second at f/5.6.*

Olympic Marmot with Paintbrush. *This big rodent grazes the wildflower meadows above timber-line. I dabbed peanut butter on some paintbrushes near its burrow to lure it within camera range of my telephoto lens equipped with an extension tube for close focusing. Canon T90, 500 mm L Canon lens, 25 mm extension tube, Fujichrome Velvia, 1/250 second at f/4.5.*

Camera Shake

Close-up techniques not only magnify the subject but also the blurring effects resulting from a vibrating or shaking camera. Handholding the camera is normally impractical except when using electronic flash. Even when mounted on a tripod the camera may vibrate excessively at some shutter speeds (usually between 1/4 and 1/30 second) due to the action of the reflex mirror.

A CAMERA SYSTEM FOR CLOSE-UPS

Although many camera types and formats can be used for close-up photography, none is better for nature subjects than the 35 mm single-lens-reflex (SLR). The major brands—Canon, Nikon, Minolta, and Pentax—have more extensive systems of close-up accessories. Canon and Nikon are the choice of most professionals.

Important Camera Features

The main advantage of the 35 mm SLR is its small size and WYSIWYG (what you see is what you get) capability made possible by the periscope-like pentaprism which presents an accurate rendering of the scene in the viewfinder. Certain features, not found on all SLRs, are necessary for high quality close-up work.

• *Depth-of-Field Preview.* This allows you to preview the scene at the aperture used during exposure, an important feature because this aperture may be smaller than the aperture at which you see the image in the viewfinder. When it is, the

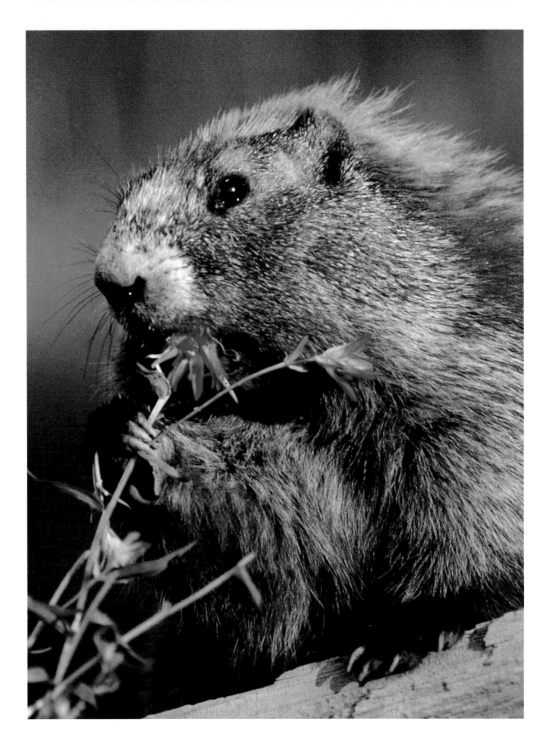

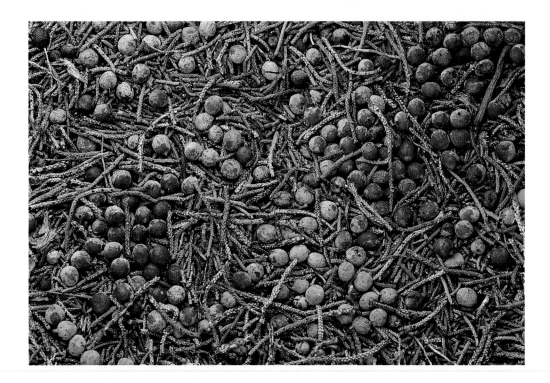

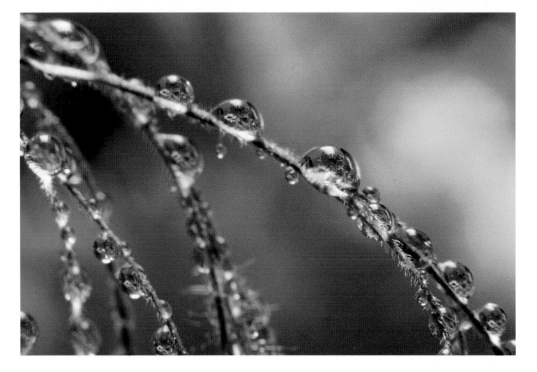

amount of the scene that is in sharp focus will be greater—an important design consideration.

• *Mirror Lock-up Device.* Just prior to exposure, the mirror that reflects the image into the pentaprism and then to the viewfinder automatically flips up to allow light from the scene to strike the film. This abrupt mechanical action creates vibrations that may blur the image. A lock-up device allows you to manually raise the mirror and delay shutter activation until the vibrations have subsided.

• *Automatic Through-the-Lens (TTL) Flash Exposure.* Electronic flashes (strobe-lights, speedlights) are often used in close-up photography. Current camera designs automatically control flash exposure even when close-up accessories and multiple flash units are used.

• *Remote Shutter Release.* To avoid camera shake, the shutter must be activated remotely, ideally by a simple electric cable. Other less desirable devices include a mechanical cable, which may be so stiff as to transmit vibrations from your hand to the camera, and a wireless, infra-red transmitter which is easily lost and must be aimed at the camera's receptor (usually from the front).

LENSES AND ACCESSORIES

Although lenses in the 50 mm to 100 mm range are used for most close-up photography, both wide-angle and telephoto focal lengths can produce dramatic effects.

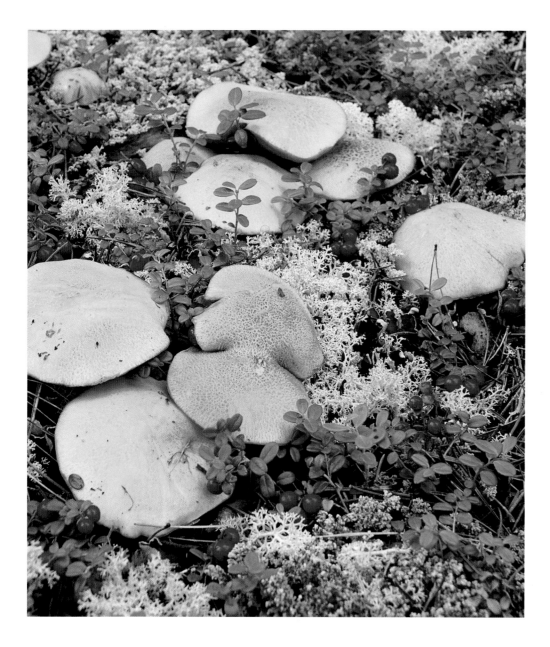

Juniper Berries and Leaves. I was drawn to the formal geometric shapes of these berries clumped beneath the overhanging limbs of a juniper tree. Canon EOS A2, 28-105 mm Canon lens (with macro focusing),12 mm extension tube, polarizing filter, Fujichrome Velvia,1/30 second at f/8.

Reflections of Gaillardia Blooms. This photograph was shot under natural light indoors where wind would not jostle the delicate scene. The droplets were created with an atomizer. Canon EOS A2, 100 mm Canon macro lens, 1.4X teleconverter, Fujichrome Astia, 8 seconds at f/16.

Fungi, Lichens, and Bearberry. One-third of the depth-of-field zone lies in front of the point of sharpest focus, two-thirds extend beyond. I positioned the depth-of-field zone by adjusting the focus distance while viewing the scene at shooting aperture. Canon T90, 100 mm Canon macro lens, Fujichrome 50, 1/8 second at f/11.

Butterfly and Alligator. *To attain adequate magnification without frightening my subject, I approached slowly and quietly with a fixed focal length 500 mm lens equipped with a 1.4X teleconverter and a 25 mm extension tube. In addition to making obvious corrections to the base photograph, the butterfly was added to the composition using Adobe Photoshop software on my desktop computer.*

Fixed Focal Length Lenses

Such lenses can be adapted for high quality close-up work with the attachment of screw-on close-up supplementary lenses (which go on the front of the prime lens just like a filter) or placing extension tubes or bellows between the lens and the camera. Standard lenses can also be stacked together for greater than life-size reproduction.

Macro-zoom Lenses

Many zoom lenses have moderate macro-focusing capabilities built in, making them highly versatile tools for recording all manner of natural subjects. Like fixed focal length lenses, they can be adapted for extreme close-up work with screw-on supplementary lenses, extension tubes, and bellows.

True Macro Lenses

These lenses are designed primarily for magnified, high fidelity recording of flat subjects — something that is rare in nature. Most types offer a continuous focusing range from infinity to one-half life-size (1:2) reproduction. The extra expense and limitations of the fixed focal length of true macro lenses may not justify the marginal improvement in quality.

Short-mount Lenses

These lenses have no built-in focusing capability. Designed for close-up work at magnifications of 1:1 (life-size) or greater when mounted on

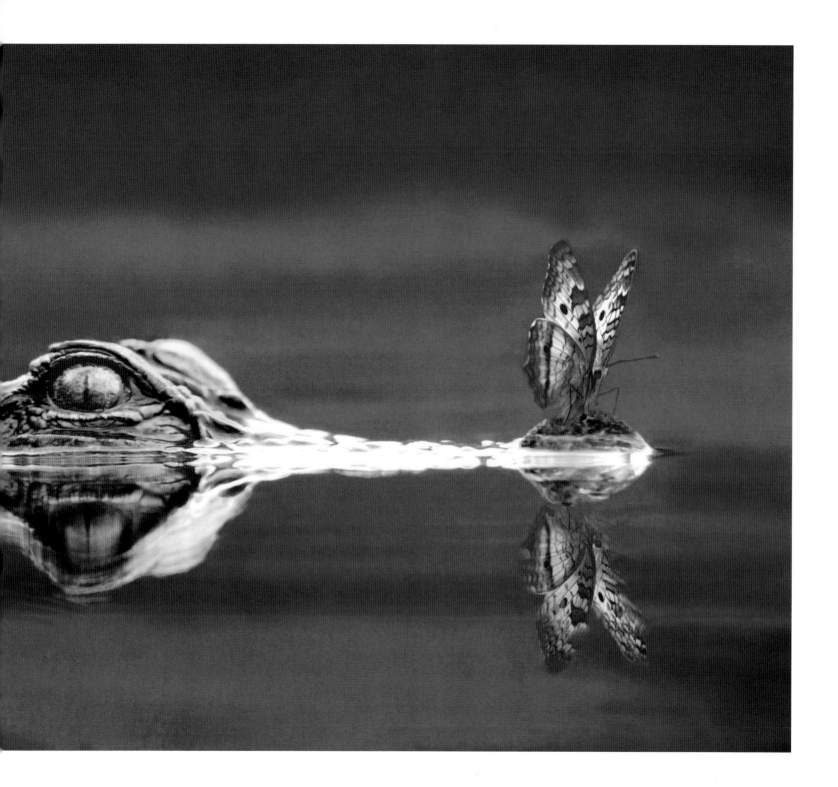

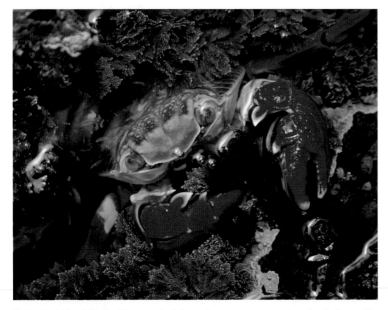 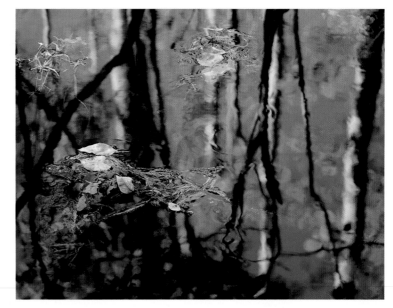

Sally Lightfoot Crab. *These colorful crustaceans scuttle for the safety of the water at the approach of a human, backing into a crevice with their powerful claws extended menacingly. A telephoto lens was equipped with a two-element, +2 diopter close-up supplementary lens to achieve adequate magnification. A polarizing filter eliminated reflections from the water's surface. Canon EOS A2, 70-200 mm L Canon lens, 500 D close-up lens, Fujichrome Velvia, 1/125 second at f/5.6.*

Swamp Reflections. *A tilt-shift lens permitted the use of the brief shutter speed that was needed to stop the slight movement of the floating leaves. At the same time it allowed me to tilt the limited depth-of-field zone to align with the plane of the subject. Canon EOS A2, 90 mm TS Canon lens, Fujichrome Velvia, 1/250 second at f/5.6.*

extension bellows, they are focused by changing the bellows extension. Because working distances with such lenses are restricted (often less than one inch) the lenses are tapered so as not to block ambient light or electronic flash from the subject.

Tilt-shift Lenses

With these optics, you can tilt and shift the front lens elements to align the film plane with the subject without changing the angle of view. This maximizes the effectiveness of the depth-of-field by positioning it most advantageously in the scene. Shifting requires larger than normal lens elements to avoid vignetting, making these lenses more expensive than comparable standard lenses. Nevertheless, tilt-shift lenses are the only way to

make fully in-focus, stop-action images of scenes which may be disturbed by the wind (a wildflower meadow for instance).

Close-up Supplementary Lenses

These inexpensive one-element lenses screw on to the front of the prime lens like a filter. They produce high-quality results at magnifications up to one-half life-size, and provide the easiest way to get started in close-up photography. Higher quality two-element supplementary lenses are available for use with telephoto focal lengths.

Extension Tubes

These hollow metal tubes fit between the prime lens and the camera body to extend the

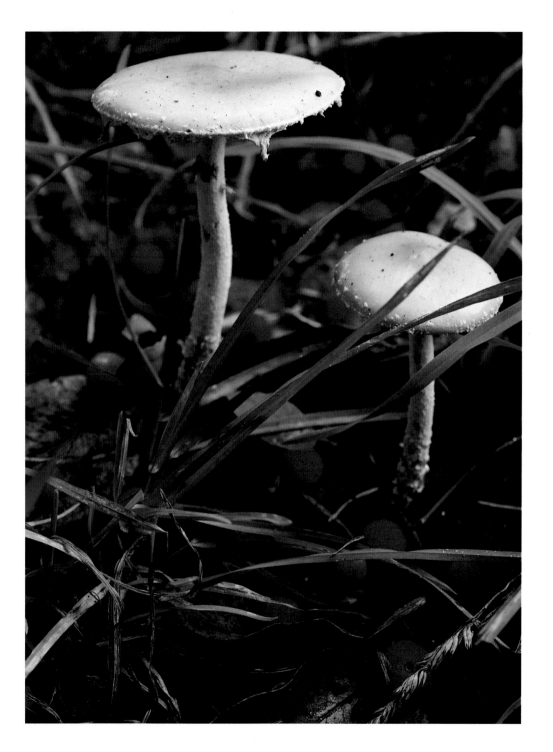

Mushrooms and Madrona Berries. *Detailed close-up images in natural light are only possible using a sturdy tripod to ensure that the camera does not move during exposure. To trip the shutter you should use a remote release or the camera's self-timer. In this composition, I positioned the depth-of-field zone to catch the leading edges of the mushrooms and tilted the camera so that the film plane (focused zone) also caught the berries in the foreground. It is usually advisable to include foreground, rather than background, elements within the depth-of-field zone because close objects naturally look sharper to the naked eye than those further away. Canon T90, 100 mm Canon macro lens, Kodachrome 64, 1/15 second at f/11.*

29

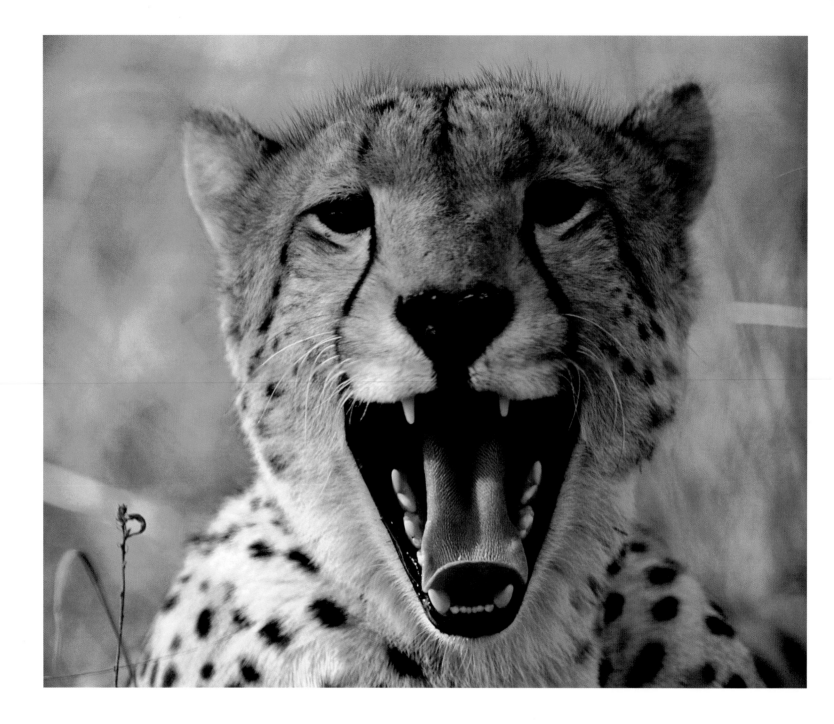

close-focusing range of the lens. They usually connect with the camera's automatic functions—auto-diaphragm, auto-exposure, TTL flash exposure, and sometimes auto-focusing. They provide excellent results at all magnifications but reduce the amount of light reaching the film.

Extension Bellows

Like extension tubes, extension bellows are placed between the prime lens and the camera body to provide close-focusing capabilities. Unlike extension tubes, they are adjustable in length, allowing variable magnification. Although they do not connect with the camera's automatic functions, they still allow convenient TTL auto-flash exposure with most cameras.

Teleconverters

These auxiliary lenses (placed between the prime lens and the camera) multiply the focal length of the prime lens while retaining its close-focusing distance, thus allowing increased magnification. Two powers are widely available—2X, which doubles the focal length of the prime lens and reduces the maximum aperture by two stops, and 1.4X, which increases the focal length of the prime lens by 1.4 X and reduces the maximum aperture by one stop.

CAMERA SUPPORTS

The problem of excessive camera shake at high magnification makes the use of a camera

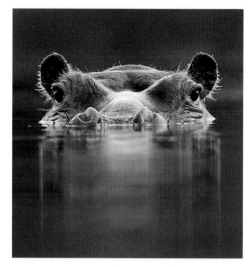

Cheetah. This yawning cat was photographed with a telephoto lens mounted on a tripod set up in the passenger seat of a Suzuki jeep. To avoid camera shake, I used an electric corded release to trip the shutter. Canon EOS A2, 500 mm L Canon lens, 1.4X teleconverter, Ektachrome EPP 100, 1/250 second at maximum aperture.

Hippos. I entered the territory of these hippos in a floating blind but kept a safe distance by using a powerful, close-focusing telephoto set-up. Canon EOS A2, 400 mm L Canon lens, 2X teleconverter (effectively producing an 800 mm f/5.6 lens), Ektachrome EPP 100, 1/250 second at maximum aperture.

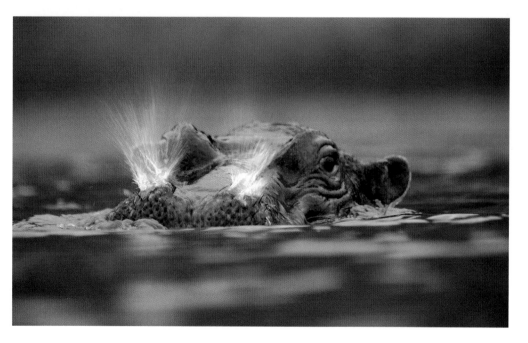

Low-angle Shooting. *One of the best ways to position the camera low to the ground is to use the Bogen Super Clamp. You can attach this inexpensive accessory anywhere on one of the tripod legs. A ball-and-socket head can be quickly fastened to the clamp to hold the camera.*

Camera and Bellows. *A double cable-release is used to stop down the lens diaphragm prior to tripping the shutter. A focusing rail allows fine lateral movement of the camera/bellows assembly while the bellows' built-in rail allows minute adjustments of the camera-to-subject distance.*

support necessary in close-up photography. The greater the magnification, the more precautions you must take to steady the camera.

Tripod

Because nature close-ups are made in the field, a lightweight tripod which can be set up on uneven ground is desirable. In addition, the tripod should be capable of low-level use for recording such subjects as wildflowers, butterflies, snails, and squirrels. Look for the following features.

• *Tubular aluminum or graphite construction for lightness and strength.*

• *Heavy duty ball-and-socket head for convenient positioning of the camera.* The levers of a pan/tilt head may limit access to the numerous controls of some close-up apparatus.

• *Tripod legs that spread at different angles for set-up on uneven terrain.* Tripods with support struts between the legs and the center column are difficult to erect on rough terrain and do not set up as low to the ground as those without support struts.

• *Removable tripod head for re-positioning the camera at ground level.* The best low-level camera support method is to attach the tripod head to the bottom of one of the tripod legs using the Bogen (Manfrotto) Super Clamp. A less convenient way is to invert the center column and hang the camera upside-down between the tripod legs.

For close-up work outdoors I like the Bogen

3021 tripod which provides good set-up flexibility, especially on uneven terrain. The lower half of the tripod's center column can be removed, allowing you to work close to ground level. For a ball-and-socket head, my preference is the Arca-Swiss Monoball 1.

Focusing Rail

This support accessory is attached between the tripod head and the camera or lens collar, and allows fine adjustments of the camera position. A single-track rail is used with a bellows (which has a built-in rail for forward/backward adjustments) and allows side-to-side adjustment of the camera. A dual-track rail provides fine adjustments of the camera position along both axes and is used with high magnification macro set-ups not employing bellows.

ELECTRONIC FLASH

From a technical standpoint, electronic flash is the ideal illumination for any type of close-up photography. The duration of the flash (1/1000 second or less) solves simultaneously the problems of camera shake and subject movement. When using flash, you can handhold the camera without fear of blurring. The intensity of the light at close range permits the use of small apertures, consequently lending much needed flexibility to the treatment of depth-of-field. Its intensity and direction can be easily adjusted. Even at close range, there is no heat given off that might harm

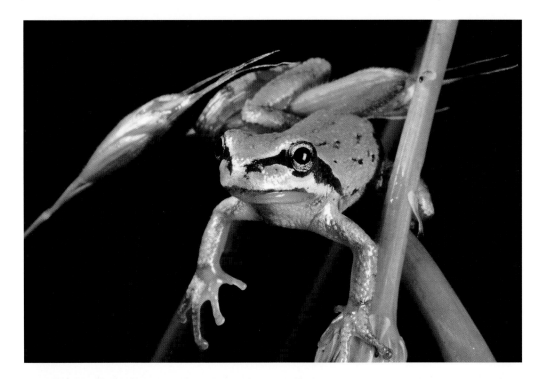

Pacific Tree Frog. *Electronic flash is especially appropriate for nocturnal creatures like this tiny frog. Canon T90, 100 mm Canon macro lens, bellows extended 100 mm, two flash units, Kodachrome 25, 1/90 second at f/16.*

Jumping Spider. *A standard electronic flash unit was used to illuminate this highly magnified scene (3:1). Exposure was controlled automatically by the camera's TTL flash control system. The flash was softened by reflecting the light onto the spider with a Lumiquest Pocket Bouncer. Canon EOS A2, 100 mm Canon macro lens, 2X teleconverter Canon Speedlite 380 EX, Fujichrome Sensia100, 1/200 second at f/8 (effective aperture of f/16).*

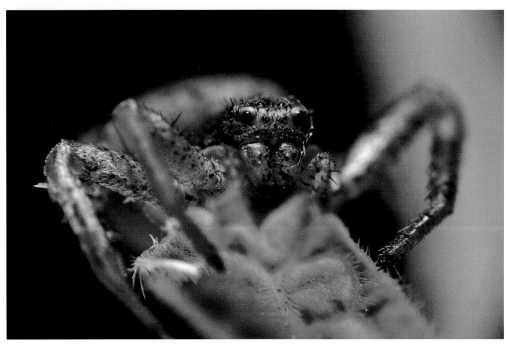

33

fragile plants and animals. Wildlife generally pays little attention to the flash after the first firing.

Automatic TTL Flash Exposure

Flash intensity is measured by the camera's TTL system so that average subjects are correctly exposed regardless of the close-up equipment being used or the distance between the flash and the subject. As when shooting under natural light, however, manual exposure compensation is necessary for subjects that are abnormally dark or light. The angle and relative intensity of flash illumination on various parts of the scene dramatically affects the mood of the image and requires special consideration by the photographer.

Macro Ring-flash

These units have circular flash tubes housed in a bracket which attaches to the front of the lens. The TTL circuitry is linked to the camera by a sync cord connected to the camera's hotshoe. With the flash thus positioned, the problem of the lens blocking light from the subject at high magnification is avoided. Most macro ring-flashes have two tubes, each with on/off switches and/or adjustable intensity to model (create shadows on) the contours of the subject.

REFLECTORS

The most natural method of modifying ambient light is to use reflectors. Usually they are used

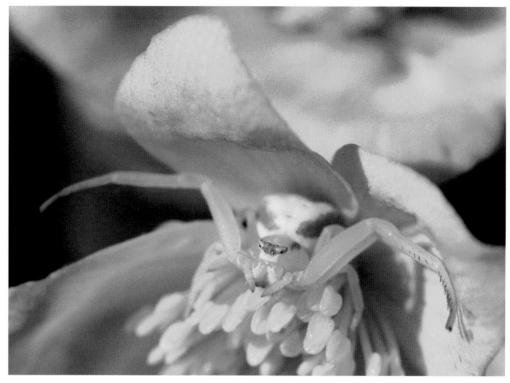

to throw light into the shaded regions of the scene to reduce overall contrast. The most useful reflectors for nature photography are made by Adorama and Flex-fill of fabric stretched inside a collapsible hoop. The dual-sided fabric can be finished in any combination of silver, gold, or white, making several reflection effects possible. With a flick of the wrist, the reflector folds up neatly to fit inside a gadget bag.

Evening Primrose and Sleepy Daisy. *An overcast sky is a photographer's best friend for producing saturated color. Canon T90, 500 mm L Canon lens, 25 mm extension tube, polarizing filter, Fujichrome Velvia, 1/60 second at f/4.5.*

Crab Spider on Marsh Marigold. *The flower blossom itself acted as reflector to reduce contrast in this scene taken under mid-day sunny conditions.*

35

Field Techniques

Field Techniques

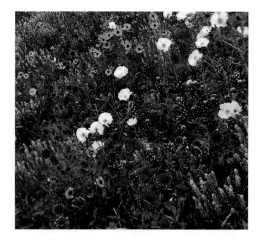

Butterfly Gardens. *Lepidoptera are especially attracted to wildflower meadows dominated by composite species such as sunflowers, gaillardias, daisies, coneflowers, and coreopsis. You will encounter the most butterflies during calm, sunny weather at midday throughout the summer.*

Painted Lady Butterfly on Purple Coneflower. *I spent about an hour photographing hungry butterflies among this clump of flowers. Sitting on the ground behind the tripod, I tried to capture a variety of lighting effects and backgrounds. An assistant used a Flexfill collapsible reflector to brighten the shadows in this variation. Canon EOS A2, 100-300 mm L Canon lens, 25 mm extension tube, Fujichrome Velvia, 1/180 second at f/5.6.*

THE DEMANDS OF CLOSE-UP photography are multiplied once you leave the comfortable environs of the studio to practise your art in nature. Wind, rain, freezing temperatures, stark lighting, difficult terrain, weak batteries, and furtive, uncooperative subjects can be added to the list of technical issues to be resolved. If you are like me, you will naturally be eager to photograph anything from a bull moose to the dew on a grass stem. However, for just two subjects like these, you likely would be unable to comfortably carry all the required equipment.

To increase your enjoyment and avoid frustration, try to limit the type of close-up work you intend to do, both in terms of magnification range and subject matter. I usually focus on just a single type of imagery for each field outing—spider portraits using multiple flash, bellows, and a normal lens; goldfinches feeding on thistles using a super-telephoto lens and an extension tube; or frost patterns on frozen leaves using a 100 mm macro lens.

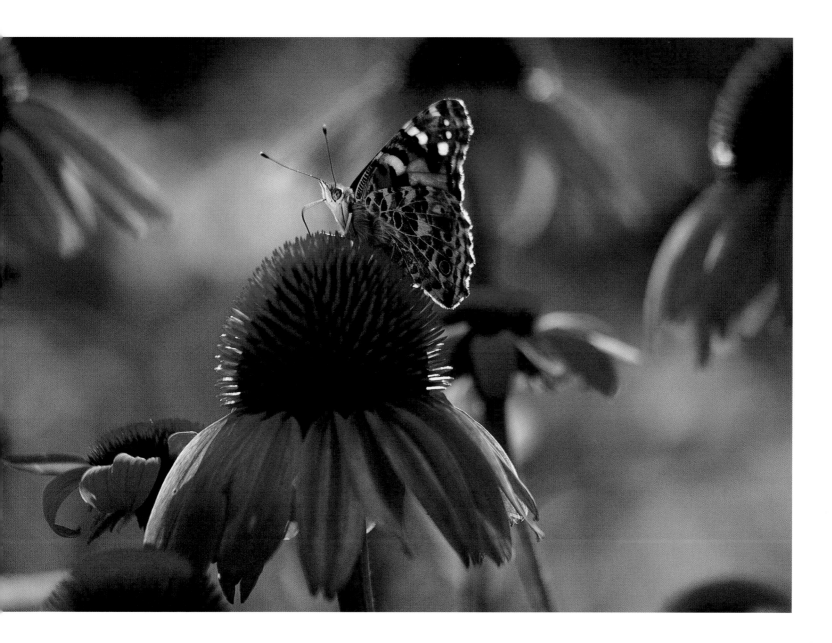

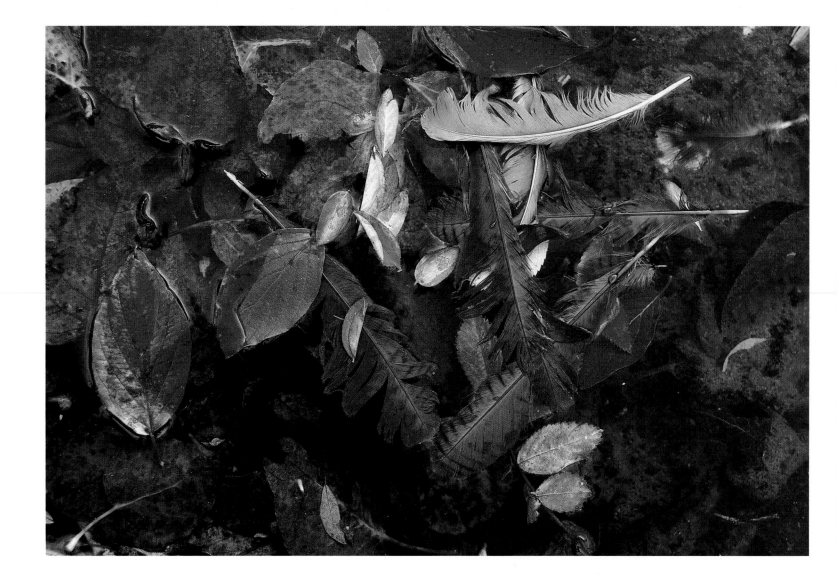

RECORDING MAXIMUM SHARPNESS

To attain maximum detail in the field, keep in mind the following suggestions.

- Use a tripod whenever possible.
- Trip the shutter with an electric release or the camera's self-timer.
- Avoid using distortion-prone, maximum and minimum lens apertures.
- Do not use the high-vibration shutter speeds from 1/4 to 1/30 second by adjusting the aperture accordingly (e.g., 1/30 second at f/11 should be changed to 1/60 second at f/8). This problem will be especially troublesome when using super telephoto lenses which are mounted on the tripod with the lens collar.
- Select shutter speeds brief enough to arrest all apparent movement of the subject.
- Lock up the mirror prior to exposure.
- Use fine-grained films. The lower the ISO rating of the film, the finer the detail it reproduces. In this respect, the best films are Fujichrome Velvia, Kodachrome 25, and Kodachrome 64.
- Avoid exposure times that cause film reciprocity failure. This is not a problem with Fujichrome Velvia, but it must be considered when using Kodachrome—at exposures of one-half second and longer, color shifts, underexposure, and grain clumping occur.
- Use appropriate optical combinations. (Refer to

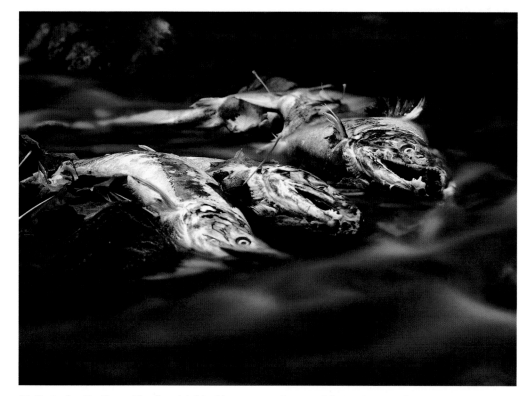

Steller's Jay Feathers. The fine detail in this image resulted from using a tripod, mirror lock-up, and a shutter speed brief enough to arrest the slight movement of the water. This was possible due to the flat field of the subject, which permitted the use of a large aperture yielding minimal depth-of-field. The high contrast nature of the scene further enhanced the impression of sharpness. Canon EOS A2, 100 mm Canon macro lens, Fujichrome Velvia, 1/60 second at f/4.

Spawned Chum Salmon. Sharpness in this image was attained by the use of an ultra fine-grained film, a low-distortion middle aperture, and a polarizing filter that reduced reflections and overall brightness, allowing the use of a long, vibration-free shutter speed. Contrast between the blurred stream of water and the immobile fish accentuates the high resolution of the center-of-interest. Canon T90, 80-200 mm L Canon lens, 25 mm extension tube, Kodachrome 25, 1/2 second at f/8.

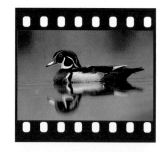

Wood Duck Drake. *I scanned this slide (top) on a Polaroid Sprintscan Plus desktop scanner and then selectively increased the color saturation and contrast on my personal computer using Adobe Photoshop software. This resulted in an image (bottom) that was closer to the color values that I remember seeing at the time the initial photograph was taken. Canon EOS A2, 400 mm L Canon lens, 1.4X teleconverter, Ektachrome Elite 100, 1/350 second at f/4.*

each optical type for specifics.)

• Position the depth-of-field zone to best advantage by using the camera's preview mechanism. For all wildlife, including insects and spiders, the depth-of-field zone should include the subject's eyes if they appear in the composition. For flowers, the pistils and stamens are most important.

• Reduce excessive ambient light contrast by using fill-in flash or reflectors.

ATTAINING BRILLIANT COLOR

Rich, saturated color is no accident. It results from numerous factors both technical and psychological. Consider the following suggestions.

• Shoot transparency films that produce saturated color— Ektachrome Elite 50 (ISO 50), Ektachrome Professional E-100S (ISO 100), Ektachrome EPP 100 (ISO 100), and the most fine-grained of these films, Fujichrome Velvia (ISO 50, which should be rated at ISO 40 for best color).

• Use a polarizing filter to eliminate reflections from wet or waxy vegetation so that the underlying color can be recorded on the film.

• Bracket exposures by 1/3 or 1/2 stop intervals to ensure that you get the best possible rendering of color.

• On sunny days, shoot in the early morning or late afternoon and position the camera so that the scene is recorded under front-lighting.

• On overcast days use a high contrast film such as Fujichrome Velvia.

Marsh Marigold and Bighorn Ram Skull. *Spraying water from this swift flowing mountain stream kept the subject damp, intensifying its color. A polarizing filter eliminated reflections allowing the film to record the full range of subject color and detail. Canon EOS A2, 100-300 mm L Canon lens (with macro focusing), Fujichrome Velvia, 1/2 second at f/11.*

Blue Flag Iris. *Mother Nature uses complimentary color theory to emphasize the hues of wildflowers, making the blossoms more attractive to insect pollinators. The yellow/purple petal pattern in this image is one of the most common. Canon T90, 300 mm L Canon lens, 25 mm extension tube, Fujichrome 50, 1/125 second at f/4.5.*

Paintbrushes and Bluebonnets. *Soft light from an overcast sky made it possible for the film to record the full range of color values in this image. In sunny weather, a matt-white reflector could be used to illuminate shadows and accomplish a similar level of color saturation, although the overall effect would appear less natural. Canon F1, 100 mm Canon macro lens. Fujichrome 50, 1/125 second at 5.6.*

Trout Lily. *The balanced illumination resulting from the use of two small manual electronic flash units mounted on macro backets provided good color saturation. Exposure was determined by tests made beforehand. One of the flash reflectors was covered with white tissue paper to reduce its power and create modelling of the subject. Canon F1, 50 mm Canon lens, extension bellows, Kodachrome 25,1/60 second at f/16.*

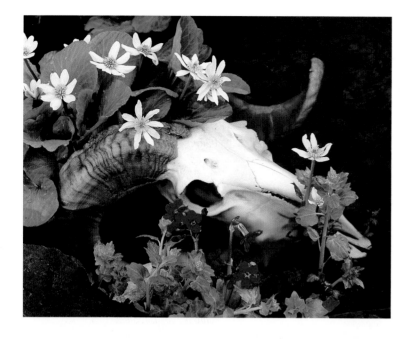
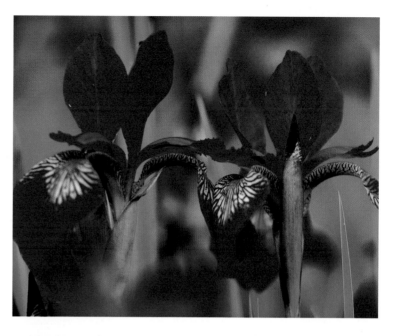
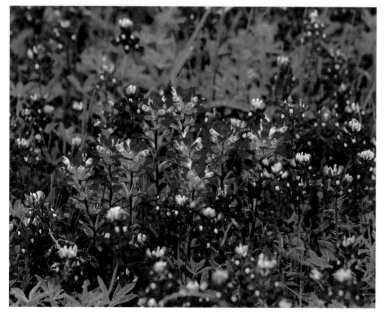

Butterfly on Rocky Mountain Bee Flower. *The telephoto lens, high magnification, activity of the butterfly, and a slight breeze made a fast shutter speed and large aperture necessary to arrest subject movement, eliminate camera shake, and achieve adequate exposure. The narrow depth-of-field that resulted blurred most of the foreground and background elements, simplifying the composition and giving emphasis to the butterfly. The complimentary green/magenta hues accentuated sharpness. I framed and pre-focused on a single blossom that was frequently visited by butterflies. When a subject landed, I was ready to begin shooting after a quick tweak of the focusing ring to bring the insect's head into the depth-of-field zone. Canon T90, 500 mm L Canon lens, 50 mm and 25 mm extension tubes, Fujichrome Velvia, 1/250 second at f/4.5.*

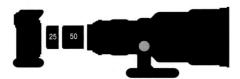

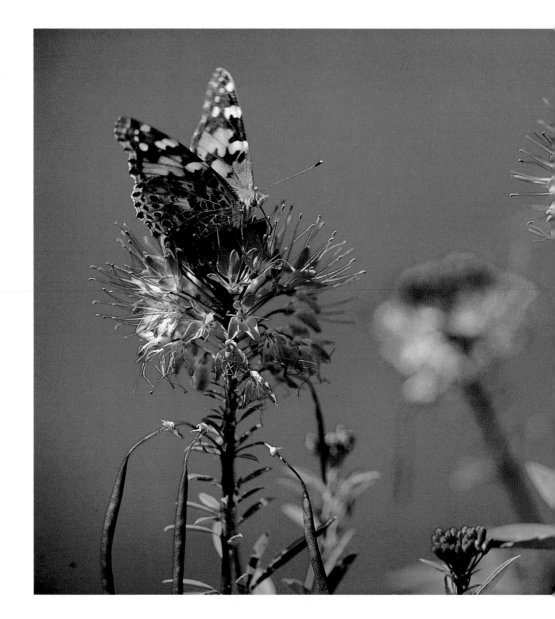

• Shoot subjects when they are wet with rain or dew. If appropriate, use an atomizer to simulate such natural conditions.

• Schedule shooting sessions to capture subjects when they are at their peak of color—wildflowers in bloom, deciduous forests in autumn, birds in breeding plumage, and so forth.

• Devise compositions that combine colors that are complimentary (opposite on the color wheel) such as yellow/purple, magenta/green, red/blue, and cyan/orange. By bringing contrasting colors into juxtaposition, they are strengthened. Such color schemes are commonly found in patches of wildflowers.

• Scan the transparency and increase its color saturation and/or contrast on your desktop computer using image editing software such as Adobe Photoshop. This may even result in more realistic color than the film was able to capture.

• Generally avoid the use of so-called color-enhancing filters, which usually produce an unnatural color cast.

• Restrict the use of warming filters to periods of sunrise and sunset when their color bias is in harmony with ambient light conditions.

CLOSE-UP FOCUSING TECHNIQUE

When shooting at high magnification at working distances of less than about one foot, focusing is accomplished by setting the magnification desired and then carefully moving the camera

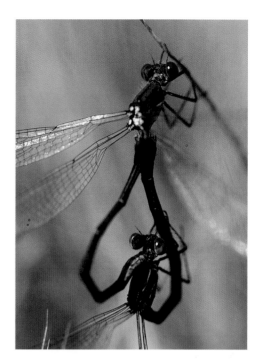

Mating Blue Damselflies. *Jostled by a breeze, these insects could not be recorded sharply unless a fast shutter speed/large aperture exposure combination was used. By careful positioning of the camera angle using a focusing rail, the limited depth-of-field that resulted was aligned to include both sets of insect eyes—the most important elements of the scene. Canon T90, 50 mm Canon lens, bellows extended about 30 mm, Kodachrome 64, 1/180 second at f/5.6.*

toward or away from the subject until it appears sharp in the viewfinder. In natural light this is done with the help of a focusing rail. If using electronic flash and handholding the camera, you should bring the camera into position with your eye away from the viewfinder. Once the set-up is in range, you can look through the viewfinder while leaning in carefully toward the subject, tripping the shutter once focus is achieved.

APERTURE/SHUTTER SPEED COMPROMISES

Many of the subjects that will interest you as a nature photographer are animate, requiring the use of brief exposures to arrest movement. Under natural light, however, fast shutter speeds must be matched with correspondingly large apertures to achieve proper exposure. As the aperture size increases, the depth-of-field decreases, which makes precise focusing critical. Unfortunately, it is difficult, and often impossible, to focus on a moving subject at close range. Although a compromise exposure setting is often the only recourse, the two techniques described below are useful in eliminating or mitigating the problem.

Placing the Depth-of-Field

When depth-of-field is limited, it should be positioned to best advantage in the composition by previewing the scene at stop-down aperture as you adjust the focus distance. In addition, you can tilt the camera so that the film plane is parallel to

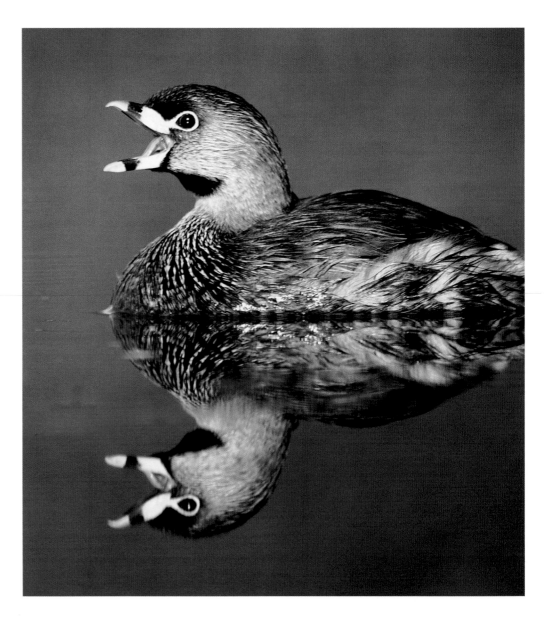

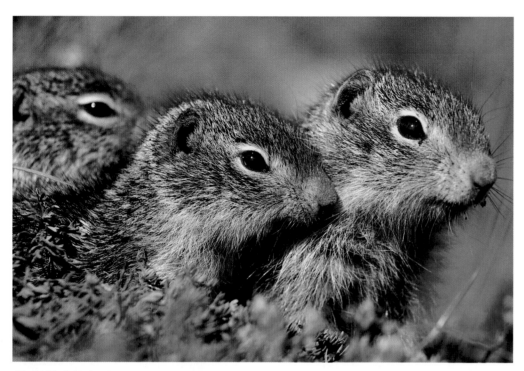

Pied-billed Grebe. *This water-level portrait of a calling grebe was shot at maximum aperture and thus required careful manual focusing to record the bird's eye sharply. Because auto-focusing systems are unable to focus with adequate selectivity, you should avoid using them in such situations when aperture and depth-of-field are constrained by the need for a fast shutter speed. Canon T90, 500 mm L Canon lens, 25 mm extension tube, Kodachrome 64, 1/350 second at f/4.5.*

Columbian Ground Squirrel Triplets. *These curious squirrels crowded the entrance of their burrow to get a view of the photographer. The burrow acted as a set that made it easy for me to predict focusing and position the camera for frame-filling magnification and an appropriate background. Canon T90, 500 mm L Canon lens, 1.4X teleconverter, 25 mm extension tube, Kodachrome 64, 1/250 second at f/4.5.*

Gaillardias. *Working in breezy conditions, I used a large aperture and brief shutter speed to arrest the movement of these composite wildflowers. The limited depth-of-field allowed the shadow edges to blur, softening the hard light of midday. Canon T90, 300 mm L Canon lens, 25 mm extension tube, Kodachrome 64, 1/350 second at f/4.*

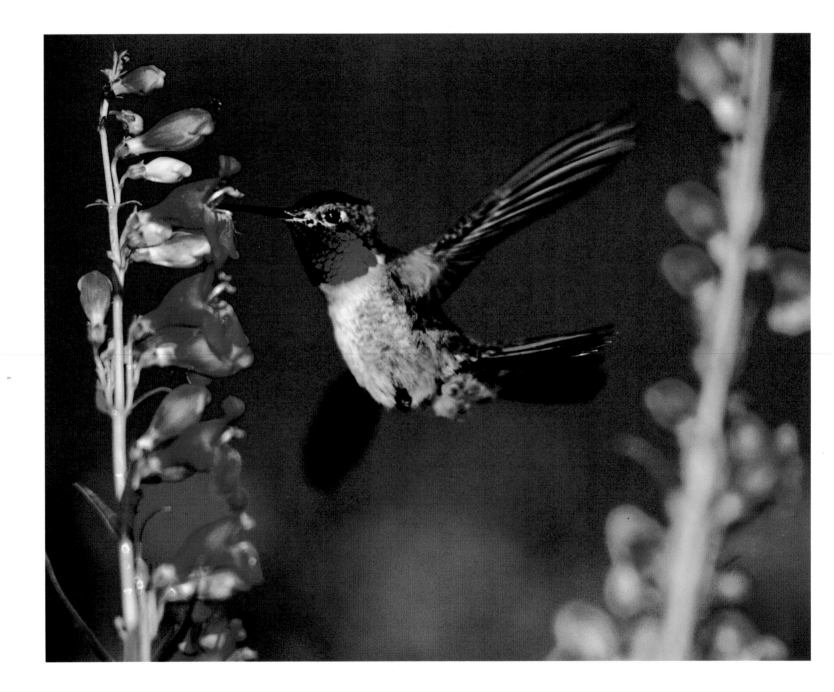

the plane of the center(s)-of-interest. After this is done, you need to refocus and shift the camera position to reestablish framing of the scene.

CREATING A SET

To make focusing as accurate and fast as possible, it helps to be able to predict the movement of active subjects. This can be done by creating picture environments (sets) which directly or indirectly control the animal's behavior. The best sets are usually those which already exist in nature and are merely incorporated into the photographic process by pre-establishing the magnification, camera angle, and focus distance. If you wish to photograph a bumble bee feeding on clover, simply frame and focus on one attractive blossom so that when the bee arrives, you need only trip the shutter. Artificial sets may be created by using bait. You can predict the activity of a chipmunk by dabbing peanut butter in an attractive location where you have set up for photography. The key to creating successful sets is to make them as natural as possible. This is most readily achieved by making maximum use of existing natural elements, such as a habitual singing perch for a song sparrow or meadowlark.

AUTOMATIC EXPOSURE PROCEDURES

Whether using electronic flash or ambient light, TTL automatic exposure works reliably in close-up photography. However, it is not as

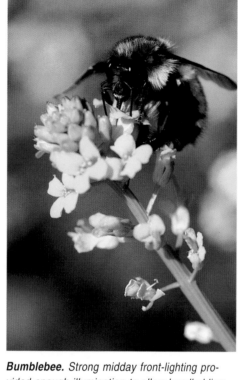

Bumblebee. *Strong midday front-lighting provided enough illumination to allow handholding the camera. I set the focusing ring for the desired magnification and then leaned in slowly toward the bee until it came into focus. Canon F1, 100 mm Canon macro lens, Kodachrome 64, 1/250 second at f/5.6.*

Broad-tailed Hummingbird. *I used an eyedropper to load sugar water into the tubular blooms of these wildflowers—a natural site which hummingbirds visited. The extra enticement allowed me to concentrate on a single stalk of blooms, framing the scene carefully and pre-focusing before the bird arrived. Although this strategy increases the time you have to photograph the hummingbird once it finds the loaded blooms, patience is still necessary. A fill-in flash with special high speed shutter synchronisation illuminated the bird's gorget. Canon EOS Elan II, 400 mm L Canon lens, 25 mm extension tube, Canon Speedlite 380 EX (set for −1.5 stops auto-fill), Ektachrome EPP 100, 1/3000 second at f/2.8.*

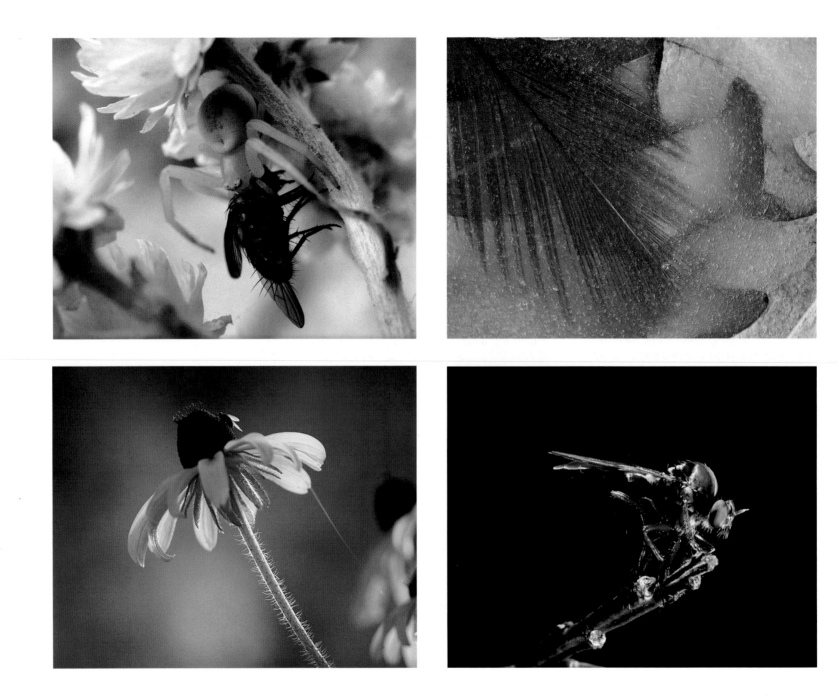

Crab Spider Eating Fly. *I made an average, full-screen exposure reading for this image due to its even tones but opened up one stop from the automatic setting to compensate for the scene's unusual brightness.*

Feather and Oak Leaves. *The automatic exposure setting for this photograph was based on an average full-screen metering pattern. No compensation was needed due to the balanced, medium tonality of the image.*

Fly. *This insect was lit by electronic flash whose output was controlled by the camera's TTL meter. The metering pattern was set to center-weighted/spot so that only the light from the fly would be considered. The unusually dark background, the result of flash fall-off, would have caused overexposure of the fly had the meter considered this area of the scene in its instantaneous calculations.*

Black-eyed Susan. *Because of the high contrast quality of the scene (a mixture of unusually bright and dark areas), I set the metering pattern for spot reading. Then I positioned the metering sensor on one of the yellow petals. Because the petal was brighter than normal, I manually increased the automatic setting by one-half stop. This ensured that the backlit petals—the most important elements of the scene—were properly exposed.*

automatic as you might wish. Two critical decisions are left to the photographer—choice of metering pattern and whether manual exposure compensation is needed.

Choosing the Metering Pattern

For low contrast or average contrast scenes, all metering patterns are likely to produce the same result. To be on the safe side, select either the average pattern (reads the entire frame on one large sensor) or the matrix pattern (averages eight to ten scattered spot measurements). For high contrast subjects, select either the spot or center-weighted pattern, position the sensor over the most important area of the scene, lock in the reading (usually done by partially depressing the shutter button), and recompose, if necessary, before taking the picture.

Making Exposure Compensations

The camera assumes each scene is average so it underexposes white/bright subjects and overexposes black/dark subjects, recording all as a medium tone. When the picture elements being read by any of the metering methods described above are unusually bright or dark, you need to manually adjust exposure using the camera's exposure compensation dial. Try using these categories when evaluating the scene to help you decide how much compensation is needed.

• *Very Bright (+ two stops).* Snow, white sand,

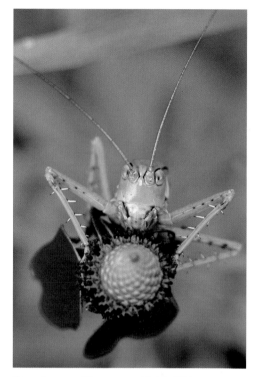

Grasshopper. *The overcast light of this scene was further softened by use of a handheld matt white reflector held below the field-of-view. The exposure was based on an average reading. Canon EOS A2, 70-200 mm L Canon lens,1.4X teleconverter, +2 diopter close-up lens (Canon 500 D), Ektachrome EPP 100, 1/125 second at f/5.6.*

ox-eye daisies, cumulous clouds, mature snowy owls, paper birch bark.

• *Bright (+ one stop).* The palm of your hand (a good built-in reference), California poppies, sunflower petals, prairie dogs, crab spiders, dew drops, dried grass, aspen bark.

• *Average (no compensation needed).* The clear north sky at midday (a reliable reference), green grass, honey bees, willow leaves, blue flag irises, chipmunks, leopard frogs, ladybugs, grasshoppers.

• *Dark (– one stop).* Black widow spiders, bumble bees, most beetles, black bears, most rain forest leaves, Douglas-fir bark.

CLOSE-UP ACCESSORY COMBINATIONS

To photograph a butterfly, should you use a 200 mm lens with a 2X converter, a 300 mm lens with a +1 diopter supplementary lens, or a 70-200 macro zoom? In fact all three combinations would work well, and with a little experience you will make such decisions routinely based on the range of equipment in your camera bag.

The many ways of combining lenses, extension tubes, teleconverters, and other accessories are resolved by the type of subject being photographed. With wild creatures your concern will be to maintain a non-threatening working distance. Regardless of the accessories being used, longer lenses produce greater working distances. Before approaching a wary subject, experiment with the

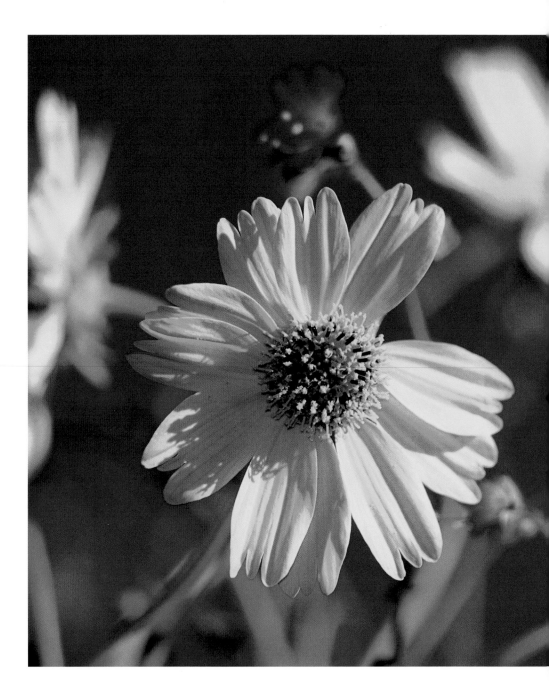

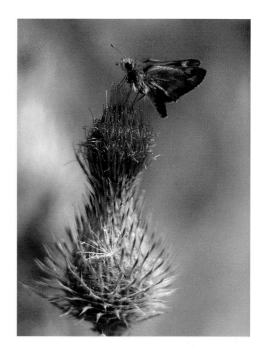

Cutleaf Daisy. *I took a low camera angle to position this flower against the deep blue of the sky. Automatic, on-camera, fill-in flash set for −1 stop was used to illuminate and retain the detail in the shadows of the daisy. Canon EOS A2, 28-105 mm Canon lens (with macro focusing), polarizing filter, Fujichrome Velvia (rated at ISO 40), 1/180 second at f/5.6.*

Skipper Butterfly on Thistle. *Wary subjects, like this butterfly, require the use of long lenses. A bellows-mounted 300 mm f/4 lens provided a working distance of about three feet. The variable extension of the bellows allows you to change both working distance and magnification easily. Bellows do not couple automatically with the lens' aperture so you must use a double cable release to stop down the aperture prior to exposure, or focus at stop-down aperture—not usually a handicap when shooting butterflies, which are active during the brightest part of the day.*

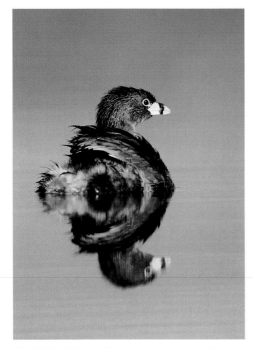

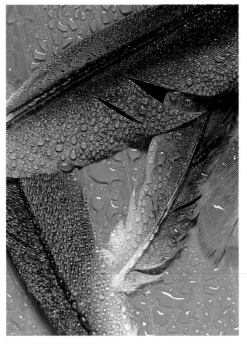

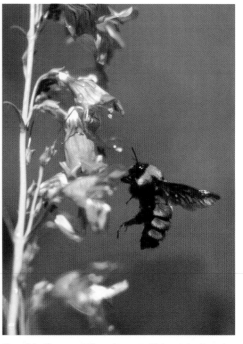

Pied-billed Grebe. *Teleconverters used with telephoto lenses do not change the focusing range of the prime lens, providing increased power at the same close-focusing distance. Canon EOS A2E, 500 mm L Canon lens, 1.4X teleconverter, Fujichrome Velvia (rated at ISO 40), 1/180 second at maximum aperture.*

Parrot Feathers. *Bellows not only provide a variable range of magnification not possible with extension tubes, but they also allow easy switching between vertical and horizontal formats. Canon EOS A2, 135 mm Komura lens, extension bellows, Fujichrome Velvia (rated at ISO 40), 1/2 second at f/11.*

Bumble Bee and Penstemon. *This portrait was made with a handheld camera (not usually recommended) made practicable here by bright sunlight, a medium speed film (ISO 100), and a +4 close-up supplementary lens, which produced high magnification without light loss. Canon EOS A2, 28-105 mm Canon lens set at 105 mm, Ektachrome EPP 100, 1/500 second at f/5.6.*

Combination Chart. *The bars on this chart (opposite page) show magnifications possible with both the prime lens and the prime lens/accessory combination. Amounts shown are estimates; actual magnification varies with the model and brand of lens.*

appropriate working distance with various combinations until you find one that is satisfactory.

For inanimate subjects, you will be concerned about perspective, which is dependant on lens focal length in the same way as photography carried out at normal magnifications.

The three devices that modify prime lenses for close-up work—teleconverters, lens extensions (tubes or bellows), and close-up supplementary lenses—may be combined singly or in combination with one another, offering innumerable ways of working close-up. If you are using a teleconverter and an extension tube together, place the teleconverter on the camera body first, then attach the extension tube, and last the prime lens.

Using Teleconverters

Teleconverters conveniently increase the focal length of the prime lens by 2X or 1.4X while maintaining the lens' full focusing range. With the lens adjusted to its closest focusing distance, magnifications of about 1/4 life-size are possible with the 2X converter and 1/5 life-size with the 1.4X converter. Teleconverters work well when combined with telephoto lenses to photograph wary subjects such as butterflies, frogs, and song birds.

About 10% loss of image quality occurs with 1.4X converters and a 20% loss with 2X converters. Fortunately image degradation takes place about the periphery of the frame and is usually not a problem, particularly when this area is not

Useful Close-up Combinations with Common Focal Lengths

Image Size / Subject Size	$\frac{1}{\infty}$	$\frac{1}{50}$	$\frac{1}{20}$	$\frac{1}{8}$	$\frac{1}{6}$	$\frac{1}{4}$	$\frac{1}{3}$	$\frac{1}{2}$	$\frac{1}{1}$	$\frac{2}{1}$	$\frac{4}{1}$
28-105 mm with macro capability	█	█	█	█	█						
28-105 mm with +4 supplementary lens	█	█	█	█	█						
28-105 mm with 25 mm extension tube	█	█	█	█	█	█	█	█			
70-200 mm with macro capability	█	█	█	█	█						
70-200 mm with +2 supplementary lens	█	█	█	█	█	█	█	█			
20 mm with 12 mm extension tube	█	█	█	█				█			
100 mm macro	█	█	█	█	█	█	█	█	█		
100 mm macro with 35 mm stacked lens	█	█	█	█	█	█	█	█	█	█	
100 mm macro with 2X teleconverter	█	█	█	█	█	█	█	█	█	█	
100 mm macro with 1.4X teleconverter	█	█	█	█	█	█	█	█	█		
35 mm short mount with ext. bellows										█	█
300 mm with 1.4X teleconverter	█	█	█	█	█						
300 mm with 2X teleconverter	█	█	█	█	█						
400 mm with 1.4X teleconverter	█	█	█	█	█						

Frame-filling Reproduction

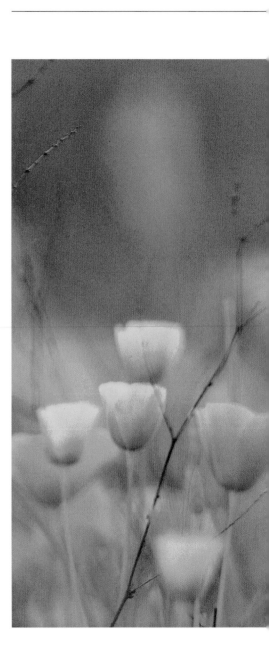

California Poppy. *The camera was positioned for this image with the help of a two-axis focusing rail and the Bogen Super Clamp, which fastened the tripod head to the bottom of one of the tripod legs. Near life-size (1:1) magnification was achieved. Canon EOS A2, 100 mm Canon macro lens, Fujichrome Velvia (rated at ISO 40), 1/60 second at f/8.*

Poppies and Lupine. *Super-telephoto lenses used at maximum aperture produce limited depth-of-field—even less at close-up distances. The out-of-focus areas in such scenes can be used as important design elements. Once I have found a suitable patch of flowers, I set up the camera and tripod, and sort through the various arrangements of blooms with my eye to the view-finder, adjusting focus distance and camera angle until I come upon a composition that I like. Canon EOS A2, 500 mm L Canon lens, 25 mm exten-sion tube, Fujichrome Velvia (rated at ISO 40),1/ 250 second at f/4.5.*

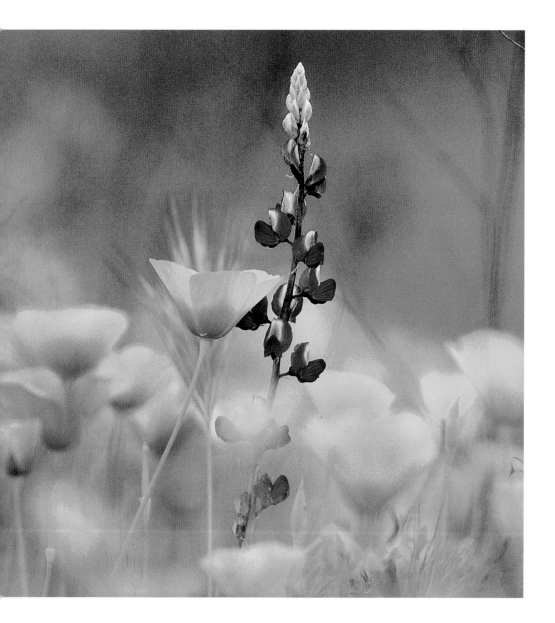

in the depth-of-field zone. If edge-to-edge sharpness is important, stop down two to three stops from maximum aperture.

Using Extension Tubes and Bellows

These devices permit varied magnification and produce quality images, even at high reproduction. On the negative side, they reduce the amount of light transmitted by the lens, which limits the range of stop-action photography under ambient light and creates problems whenever you are working in the wind.

Magnification can be estimated by dividing the amount of extension by the focal length of the prime lens. A 50 mm lens with 50 mm of extension produces magnification of 50/50 or 1/1; a 100 mm lens with 50 mm of extension produces magnification of 50/100 or 1/2 life-size.

Most extension tubes couple to all of the camera's automatic functions, except auto-focus (rarely a handicap). All automation is lost when working with bellows except TTL flash. A double cable release can be attached to provide automatic diaphragm operation. Bellows allow the camera to be rotated between vertical and horizontal formats or any angle in between, a convenient feature not possible with extension tubes except for the Nikon PN-11 tube, which has a rotating tripod collar.

Bellows are designed primarily for high magnification work. Most have a minimum extension

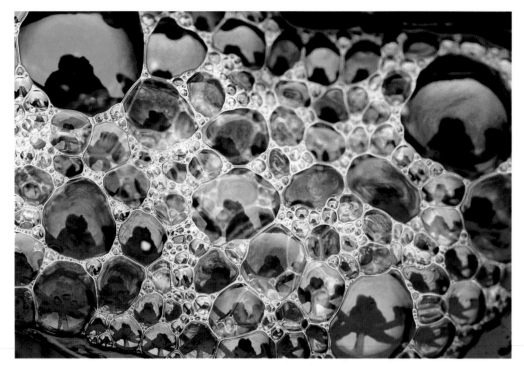

Surf Line Bubbles. *Bubbles which form along the edge of incoming surf are not as still as you might think. One bubble or another regularly pops, causing the entire mass to regroup. Fortunately the photographic field is fairly flat, making the use of a large aperture (adequate to bring all of the bubbles into focus) and brief, action-stopping shutter speed possible. Canon EOS A2, 100 mm Canon macro lens, Fujichrome Velvia (rated at ISO 40), 1/60 second at f/2.8.*

Wild Aloe Vera and Ferns. *My eyes widened when I discovered these stiff, succulent, richly colored leaves. Little affected by wind, they permitted me to use a slow shutter speed and the small aperture necessary to bring the thrusting branches into the depth-of-field zone. Canon EOS A2, 20 mm Canon lens, +3 close-up supplementary lens, Fujichrome Velvia (rated at ISO 40), 1/2 second at f/11.*

of around 50 mm. So with a 50 mm lens, the minimum magnification is nearly life-size. With a 100 mm lens, it is about 1/2 life-size.

Bellows are constructed with two sets of rails —one for changing camera position, the other for adjusting the extension. When using a bellows, spread the boards for the magnification desired, then adjust the position of the entire assembly on the focusing rail until the scene is sharp. If you are too tight on the subject, decrease the extension; if you are not tight enough, open the bellows further; then readjust the camera position.

Using Close-up Supplementary Lenses

These lenses do not reduce the amount of light transmitted through the optical system, giving them an advantage over lens extensions when ambient light is low. They fit prime lenses with matching filter diameters, which means you likely need to acquire more than one set to fit all of your lenses, or use step-up/down rings, which may cause vignetting.

A supplementary lens is classified by its diopter rating, which is the inverse of the close-up lens' focusing distance in meters. A +1 diopter refocuses the prime lens (set at infinity) to a distance of 1/1 meter, a +2 diopter to 1/2 meter (500 mm), a +3 diopter to 1/3 meter (333 mm). Not all manufacturers use this method for naming their lenses. For example, Canon close-up lenses "250" and "500" focus at 250 mm (+4 diopters)

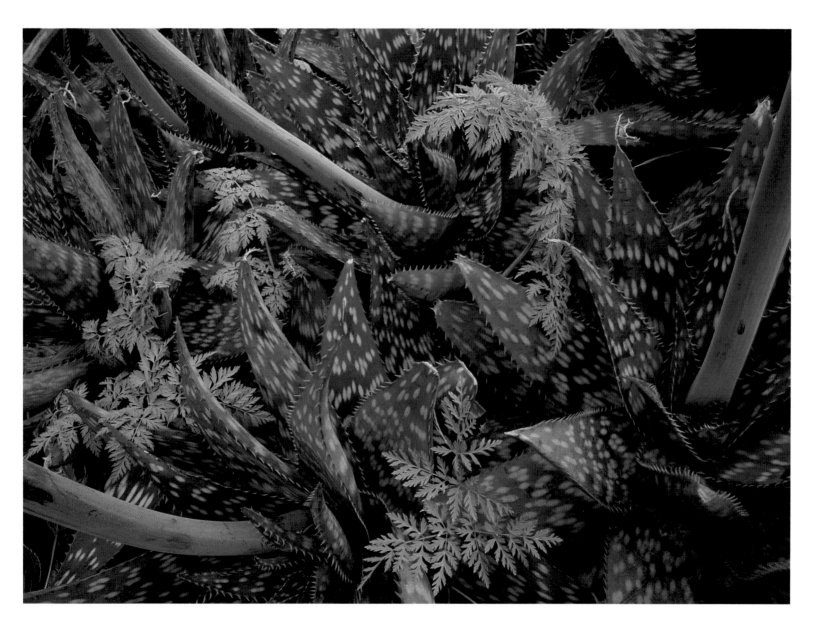

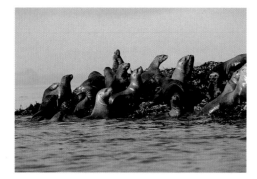

Northern Sea Lion. *When shooting wary creatures in situations where it is difficult to predict working distance or magnification, a zoom lens and teleconverter provide a versatile, quick working combination. For these sea lions, shot from a rocking boat in Alaska, a handheld approach was necessary. I used a zoom lens with macro-focusing capability set for continuous auto-focus, keeping one hand on the zooming ring to control subject magnification and the other on the shutter button for rapid response to the animal's behavior.*

When the conditions require that you shoot without benefit of a tripod, such as when working from water craft or in a forest where you must change position frequently to keep the subject in view, image stabilization (IS) lenses, currently manufactured by Canon, greatly improve subject sharpness, allowing you attain the same image quality at shutter speeds up to two stops slower. Canon EOS A2, 70-200 mm L Canon lens, 2X teleconverter, Fujichrome Sensia 100, 1/350 second at maximum aperture.

Saw Whet Owl. *Due to poor optical quality, limited light transmission, and camera vibration during exposure, I rarely use a 2X teleconverter with super-telephoto lenses. However, in this instance a confiding subject (the owl was photographed at a raptor rehabilitation facility) and still atmosphere reduced these problems, permitting the use of a slow shutter speed, small aperture, and mirror lock-up. Canon EOS A2, 400 mm L Canon lens, 2X teleconverter, Fujichrome Velvia, 1/8 second at f/5.6 (effective aperture of f/11).*

and 500 mm (+2 diopters) respectively. The higher the diopter rating, the smaller the working distance and the greater the magnification. Close-up lenses do not provide a significant magnification increase when used with lens extensions.

Single element close-up lenses do not produce high quality results at magnifications exceeding about 1/3 life-size. Corrected, multi-element supplementary lenses are available from some manufacturers, such as Nikon and Canon, for use at high magnification and with zoom and telephoto lenses.

USING TELEPHOTO LENSES

Telephoto lenses allow you to maintain adequate working distance from wary subjects. They can be used with teleconverters, extension tubes and bellows, and close-up supplementary lenses, as well as nearly any combination of all four. One of my favorite uses of a telephoto lens in close-up work is for shooting wildflower meadows at maximum aperture. With careful manipulation of camera position and focus distance, you can use the shallow depth-of-field to create dramatic abstractions organized around out-of-focus background and foreground elements.

USING WIDE-ANGLE LENSES

Adapting a wide-angle lens for close-up work is best accomplished with a short extension tube (12–15 mm). At close range it creates the same

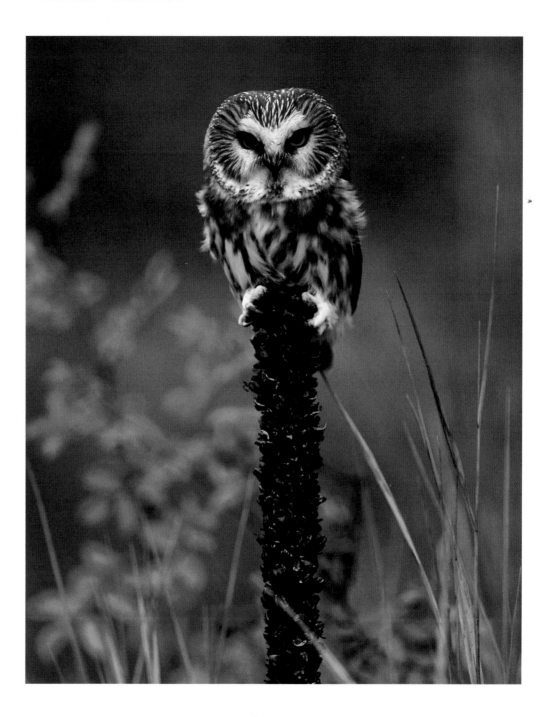

Indian Blanket Meadow. *This foggy, dreamlike effect is the result of a double exposure. One exposure was made with the lens de-focused to blur the subject. The other was made with precise focusing, a large aperture for minimum depth-of-field, and fill-in flash from the camera's built-in unit. Each exposure was made at 1/2 stop under the meter's indication to yield the correct cumulative exposure. Canon EOS A2, 28-105 mm Canon lens set to 28 mm, Fujichrome Velvia (rated at ISO 40).*

California Poppies *. Photographing wildflowers from below against the blue sky is one of the few ways such subjects can be pleasingly recorded during midday sunny conditions. These poppies were shot handheld with an ultra-wide-angle lens, the camera resting partially on the ground to gain extra stability. The blooms in the foreground are almost touching the front of the lens, making the slightest change in camera angle critical to the composition. A circular reflector was used to throw light onto the shadow side of the blossoms. A brief shutter speed was necessary to stop the movement of the flowers in the wind. Canon EOS A2, 20 mm Canon lens, 12 mm extension tube, Fujichrome Velvia (rated at ISO 40), 1/180 second at f/6.3.*

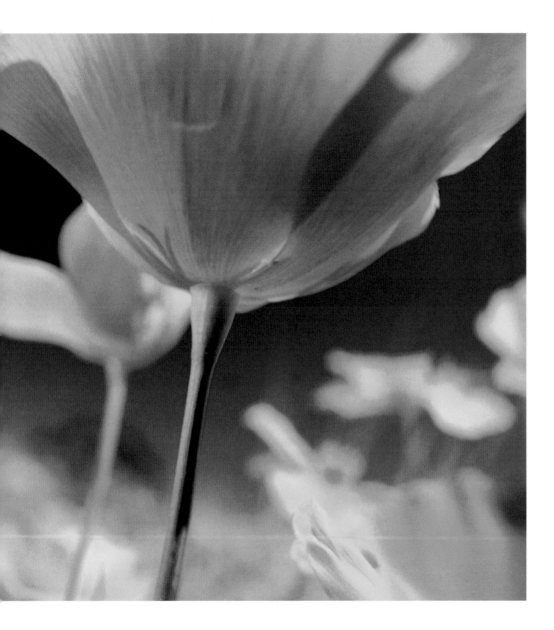

feeling of expanded perspective as at normal magnification. When using close-up supplementary lenses, vignetting may occur with focal lengths less than 24 mm. This can be checked by viewing the scene at stopped-down aperture. Most viewfinders only show about 90% of the picture area, so vignetting may still appear on the film. I like to push a wide-angle lens into a clump of flowers, with some of the blossoms even touching the front of the lens. Then, working with the camera handheld at ground level, I try various positions—changing the angle even slightly can radically alter composition.

Wide-angle lenses are useful for producing magnifications exceeding life-size with minimum extension and therefore minimum light loss through the optical system. In order to focus at such magnifications, the lens is attached in reversed position to the tubes or bellows. A reversed 24 mm lens with 50 mm of extension produces 2X (2:1) life-size; with 150 mm of extension, it produces 6X (6:1) life-size.

USING TILT-SHIFT LENSES

These lenses make maximum use of depth-of-field—close-up photography's most limited commodity—making it possible to use larger apertures and faster shutter speeds that freeze motion. Tilt-shift lenses allow the film plane to be aligned with the subject plane with minimal framing compromise. First establish the framing

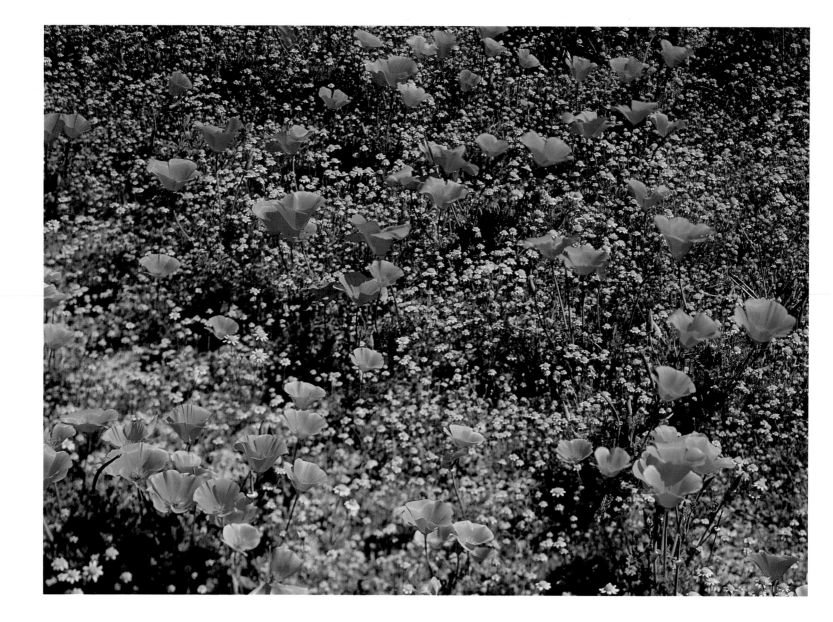

desired, then tilt the lens to parallel as closely as possible the important elements of the composition, adjust focus, and reposition the camera to capture the scene as originally framed. Finally, using depth-of-field preview, select the aperture and shutter speed combination that best interprets the scene. Keep the shift settings set to "zero" to avoid exposure problems.

Tilt-shift lenses can be used with extensions, teleconverters, and close-up supplementary lenses. They are available from Canon or Nikon in focal lengths ranging from 24 mm to 90 mm. The longer focal lengths generally are more useful for natural subjects.

GREATER THAN LIFE-SIZE MAGNIFICATION

At magnification exceeding life-size, the image quality of standard lenses begins to deteriorate and working distances are so reduced that light may be blocked from the subject by the lens itself. Special procedures are necessary to avoid these problems.

Reversing the Lens

Image quality is restored by reversing the lens on the camera body, accomplished by screwing an adapter to the front of the lens. Unfortunately the adapter circumvents automatic coupling devices and makes stop-down metering, manual closing of the diaphragm, and manual exposure control necessary.

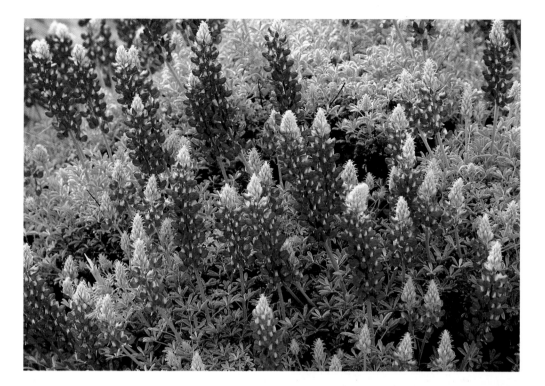

California Poppies and Eriophyllum. In the open terrain of the Antelope Valley of California, where this photograph was taken, wind is a constant harrassment to recording blur-free views of the beautiful meadows. A tilt-shift lens allows you to bring the film plane into near parallel alignment with the meadow without having to resort to a camera position that is directly overhead. As a result, a large aperture/fast shutter speed combination can be used for exposure. Canon EOS A2, 90 mm TS Canon lens, 2X teleconverter, Fujichrome Velvia, 1/350 second at f/5.6.

Desert Lupines. Due to constant breezes, the same technique described above was needed for these lupines. A 2X teleconverter was placed between the camera body and the tilt-shift lens for added magnification (pictured right).

Red-flowered Currant Blossoms. *These comparative images demonstrate the great atmospheric difference in photographs made with natural light (left) and with two electronic flashes (right). The electronic flashes created a dark, artificial background (the result of flash fall-off). The natural light version required a perfectly still day to attain sharpness in the shaded forest setting. Both images made with a bellows and 50 mm lens at about 0.75X life-size magnification.*

Crab Spider. *This tiny specimen, intent on capturing insects visiting the flower, was photographed with a handheld camera, made possible by the brief duration of the flash which insured sharpness for this 3X life-size rendering. Canon EOS A2, 50 mm Canon lens reversed-stacked on 135 mm Komura lens, Canon 380 flash, Lumiquest Pocket Bouncer, Fujichrome 100, 1/125 second at f/11.*

Using Short-mount Lenses

These tiny wide-angle lenses are designed to be used at greater than life-size reproduction, so reversing them is not necessary. Short-mount lenses are usually tapered to allow light to strike the subject from the front. They do not have integral focusing mechanisms, so all focusing is done by positioning the camera/bellows/lens apparatus at the focused distance (done with the aid of the focusing rail on the bellows). The correct extension is set first and then the apparatus is moved along the rail until focus is achieved. For best results, choose an aperture two to three stops smaller than the maximum.

Using Stacked Prime Lenses

This aproach uses two prime lenses attached back-to-front. It is useful for shooting small, active insects. Working distances are greater than equivalent set-ups using lens extensions. The camera/lens combination can be handheld using electronic flash controlled automatically by the camera's TTL system. If working with ambient light, a focusing rail is necessary due to the high magnification.

The longer lens, which is attached to the camera, couples fully to all automatic functions except auto-focusing. The shorter lens is mounted to the long lens filter threads to filter threads. If you do not have an adapter ring (available from several suppliers—see the appendix), the lenses

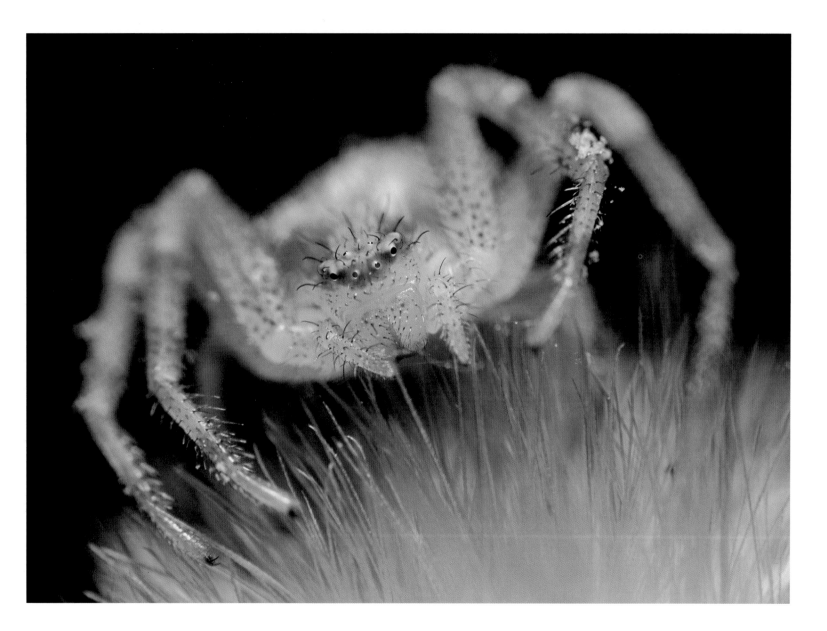

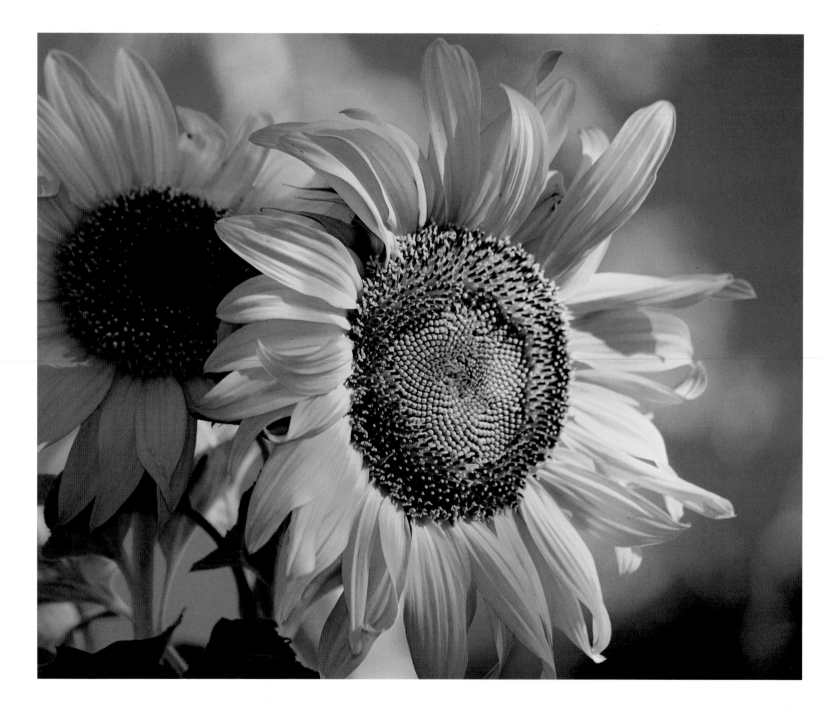

can be taped together. Magnification is roughly derived by deviding the focal length of the longer lens by the focal length of the shorter lens. To focus, you move in toward the subject until it lies in the depth-of-field zone. (Viewing is at maximum aperture.)

Cheap, secondhand, manual-focus lenses are perfect for this type of macro work. The combination I use most is a 135 mm f/3.5 with a 50 mm f/1.4, which produces a magnification of about 2.7:1. You may have to try several combinations before finding a pair of lenses that works together without vignetting. Keep the following points in mind:

• Try combinations that produce between 4:1 and 2:1 reproduction.

• Use fixed focal-length (including macro) or moderate zoom lenses for the longer lens. Focal lengths between 135 mm and 200 mm are best.

• Use fixed focal-length, large aperture lenses for the shorter lens. The shorter lens should have a filter diameter equal to, or greater than, the longer lens.

• If vignetting occurs, insert an extension tube between the camera body and the longer lens.

WORKING WITH ELECTRONIC FLASH

The main advantages of working with electonic flash are reliable automatic TTL exposure control, brief exposure times which allow handholding, adequate illumination for exposing fine-grained films at small apertures, which maxi-

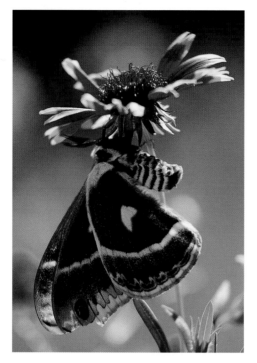

mizes depth-of-field. Electronic flash is often the only viable approach for recording small animals at magnifications 1:2 or greater. The disadvantage is the artificial quality of the lighting, which can be minimized by using bounce reflectors.

Full Flash or Fill-in Flash?

Full flash is used to light both the subject and background; no ambient light registers its effect on the film. This type of lighting is thematically suited for images of nocturnal subjects in which portions of the background are black due to flash fall-off. With the notable exception of butter-

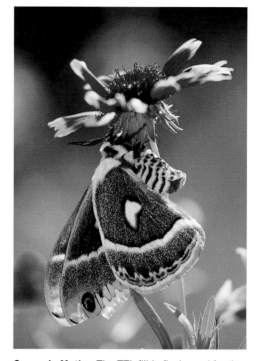

Cecropia Moths. *The TTL fill-in flash used for the image on the right was adjusted to produce 1.5 stops less light than full exposure in order not to overpower the natural light. Nevertheless, the effect appears unnatural due primarily to the mid-day setting, a time when shadows are rarely illuminated by natural light reflections.*

Sunflowers. *Taken early in the day, the on-camera fill-in flash evident in this image is more in harmony with natural lighting conditions. Canon EOS A2, 28-105 mm Canon lens (set for macro focusing), polarizing filter, Ektachrome EPP 100, 1/125 second at f/8.*

Gray Squirrel (black phase). *Multiple flashes were set up above and in front of this hungry rodent, which was sitting on a bird feeder digging through a heavy snowfall for seeds. The snow reflected light back into the scene, resulting in crisp but even illumination. The two manual flash heads were wrapped with Kleenex tissue to soften their effect. Canon F1, 200 mm Canon lens, bellows (extended about 20 mm), Kodachrome 64, 1/160 second at f/8.*

Multi-flash Set-up. *Shown here is the Lepp bracket (designed by George Lepp), which can be used for hands-free placement of two flashes. The flashes must be connected to the camera with dedicated sync cords for automatic TTL exposure. To show the texture and three-dimensional shape of the subject, one of the flashes should be reduced in power by one to two stops. If possible, attach the flash bracket to the bellows so that the camera body can be rotated between vertical and horizontal formats while maintaining the same lighting arrangement.*

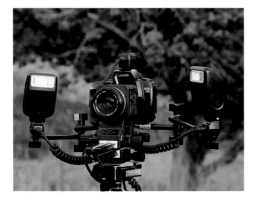

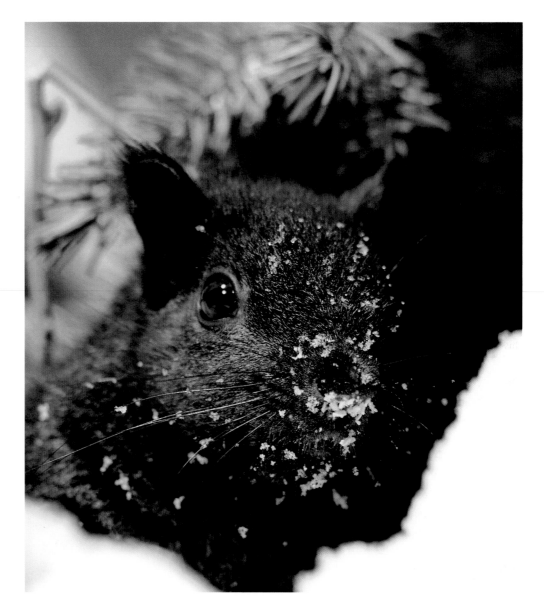

flies, bees, and other pollinators, most insects can be included in this category, as well as many species of reptiles and amphibians. Full flash is also necessary, due to its brief duration, when handholding the camera at high magnification.

Fill-in flash provides a handy way of illuminating the shadows of a scene so that detail in these areas can be recorded by the film. It does about the same job as a reflector except it creates an artificial, specular highlight in the eye of an animal and its effect cannot be as easily judged prior to exposure. The fill-in flash should be about two stops less than the overall exposure. Most cameras allow you to set this using the exposure compensation dial. I use fill-in flash with a sheet of tissue wrapped around the reflector to soften the light. The TTL system compensates for this automatically.

Flash Synchronization

With full-flash, set the camera's shutter to its highest flash synchronization speed (most cameras do this automatically). This minimizes the possibility of ambient light creating ghost images in the scene. With fill-in flash, you give priority to the ambient exposure settings of f/stop and shut-'ter speed, provided the shutter is set at the flash sync speed (or slower).

Positioning the Flash

The more natural the flash appears, the

Eastern Painted Turtle. *Light from a single electronic flash unit softened by a layer of Kleenex placed over the flash reflector provided the soft side-lighting for this scene. The flash was handheld at arm's length from the tripod mounted camera. When making animal portraits, I try to position the flash so that the subject is looking into the light, which produces strong illumination on the most interesting part of the animal. The moderately elevated camera angle placed the camera about equal distance from the subject and background, providing even light throughout the scene. Canon F1, 300 mm L Canon lens, extension bellows, Kodachrome 64, 1/60 second at f/8.*

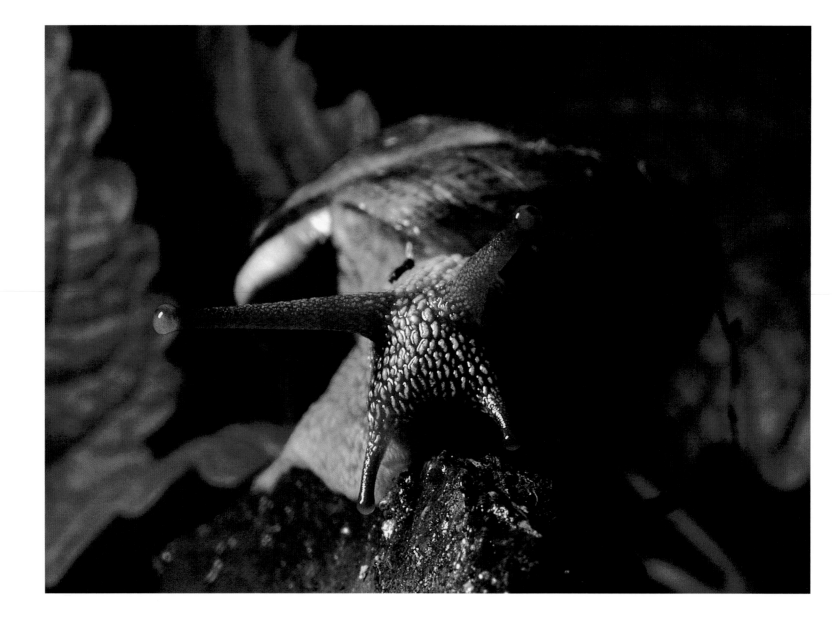

better; in nature, light illuminates the subject from any direction, and so can your flash. The most convenient position for the flash is on the camera's hot shoe, but you can also place it to one side, above, or even behind the subject using a remote synchronization cord and a macro-flash bracket or light stand. If you use multiple fill-flash, be sure that one flash dominates the lighting scheme by reducing the effect of the other flashes. Generally, the background light should be reduced by one stop (or more) and a fill-in light should be reduced by about two stops.

Using Macro Ring-flash

Aside from its smaller size, a macro ring-flash has no significant advantage over two normal flash units used with macro brackets. When using normal or wide-angle lenses at high magnifications (greater than life-size), the fixed rings of a ring flash are sometimes too far from the camera/subject axis to illuminate the scene. At greater distances they provide little flexibility in creating lighting effects, producing mainly frontal lighting with minimal modeling, even with dual tube, variable power flashes.

Pacific Land Snail. One flash, softened by a layer of Kleenex placed over the reflector, positioned to the side of the subject, creates a high contrast scene. The brief duration of the flash permitted handholding of the camera/bellows apparatus.

Beetle. A single flash placed directly above the subject provided even illumination throughout the image. At close range and high magnification (here about life-size), the relatively large size of the reflector (several times larger than the field-of-view) of even a small flash throws light evenly over the scene if the flash is positioned above and in front of the scene.

CHAPTER THREE

Artful Approaches

Artful Approaches

U NACCUSTOMED TO EXAMINING the environment at close range, most beginning photographers benefit from having few preconceived notions of what makes an interesting close-up image. Clichés which may stifle originality in normal natural history photography—mountains framed by foreground trees, waterfalls blurred by slow shutter speeds, elk bugling in snowy meadows—are generally not accessible to close-up practitioners. As a result their imagery springs from open minds and fresh visions.

Creativity cannot be expressed effectively unless it is presented to the viewer on a framework of sound composition. Should you wish to review the fundamental principles of picture design, texts listed in the appendix provide comprehensive information for composing nature photographs. This chapter presents several easy methods for strengthening composition skills you have already developed and suggests new directions for your artistic efforts.

DESIGNS OF THE SUBJECT

I usually devise compositions by reacting to what the natural setting offers, rather

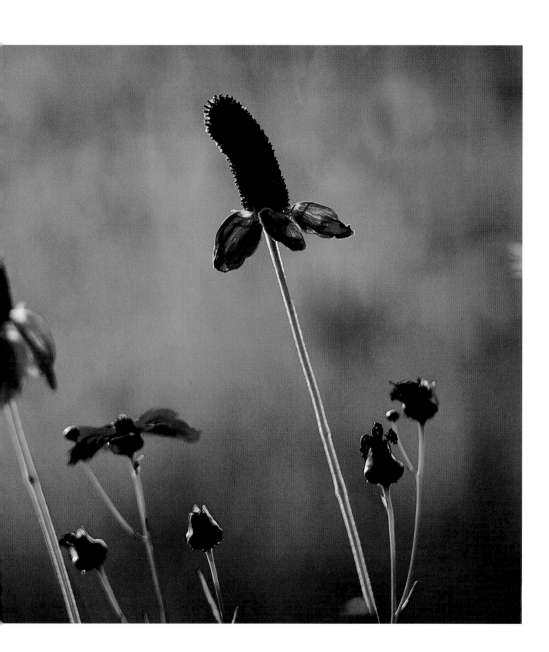

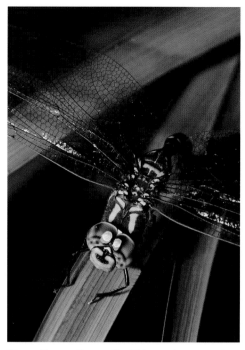

Green Darner Dragonfly. *This creature was photographed in the early morning when it was still inactive due to the cold temperature. Canon T90, 50 mm Canon lens, extension bellows, two electronic flash units on macro brackets, Kodachrome 64, 1/90 second at f/16.*

Mexican Hat Wildflowers. *I positioned the camera to photograph the shaded side of these wildflowers knowing that the sun would illuminate the colorful translucent petals and the furry edges of the stems. The camera angle was adjusted to bring the orange petals close to the purple blurs in the background to increase apparent color contrast. Canon EOS A2, 500 mm L Canon lens, 25 mm extension tube, Fujichrome Velvia (rated at ISO 40), 1/180 second at f/ 5.6.*

Prairie Crocus. *Mother Nature knows the value of placing contrasting colors together. Here the nearly complimentary mauve and yellow hues strengthen one another, increasing their attraction to insect pollinators. Nikon F, 200 mm Nikkor lens, extension bellows, Kodachrome 64, 1/125 second at f/8.*

Frozen Leaves. *Soft light from an overcast sky and a polarizing filter, which reduced the reflections from the leaves, resulted in rich color. Canon EOS A2, 100 mm Canon macro lens, Fujichrome Velvia (rated at ISO 40), 1/15 second at f/11.*

Prickly Pear Cactus. *The interplay of related hues creates an interesting study of color harmonies and automatically produces a unified composition. In pattern-based designs such as this, make sure that the center of the frame (the most attractive area, all else being equal) falls within the depth-of-field zone. Canon EOS A2, 28-105 mm Canon lens (with macro focusing), Fujichrome Velvia (rated at ISO 40), 1/15 second at f/8.*

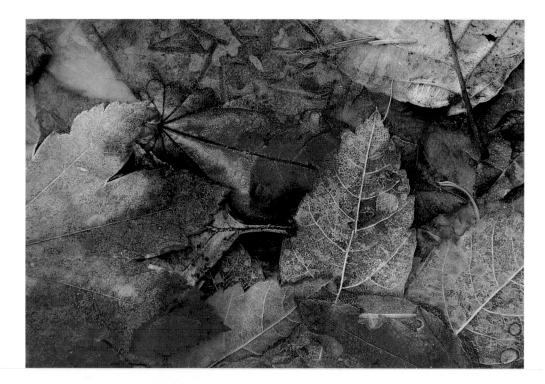

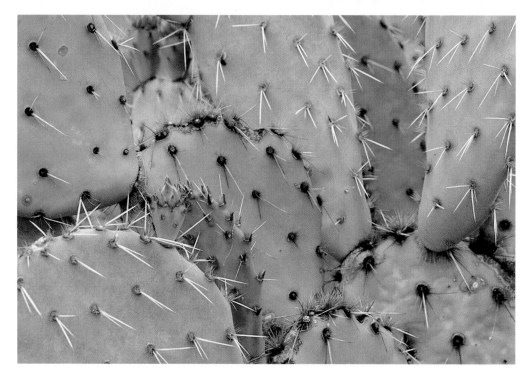

than working from a preconceived plan or formal design concept (such as the rule of thirds). When I come upon a subject that I think would make a good photograph, I move around it with a handheld camera, previewing various angles, magnifications, and focal lengths to get an idea of how I would like to position the tripod. The difficulty of repositioning the tripod may cause you to miss the most effective rendering of the scene if you don't do some exploratory framing first. Just don't neglect to set up the tripod before you begin making exposures!

NOTHING BUT COLOR

When I'm prospecting for a photograph, I look for strong color or interesting color relationships above all else. The most important and dynamic part of our visual psychology, color speaks in many accents. Saturated, contrasting hues are the most exciting and a composition based on these values rarely fails to create a compelling image. However, as a photographer's color experiences accumulate, he becomes equally receptive to the delicate sensations that emanate from combinations of related hues. The beauty of such scenes is usually best expressed by designs that are direct and simple.

NATURAL LIGHT: FOUND ART

Light follows color on my list of important picture components. I'm not concerned about the

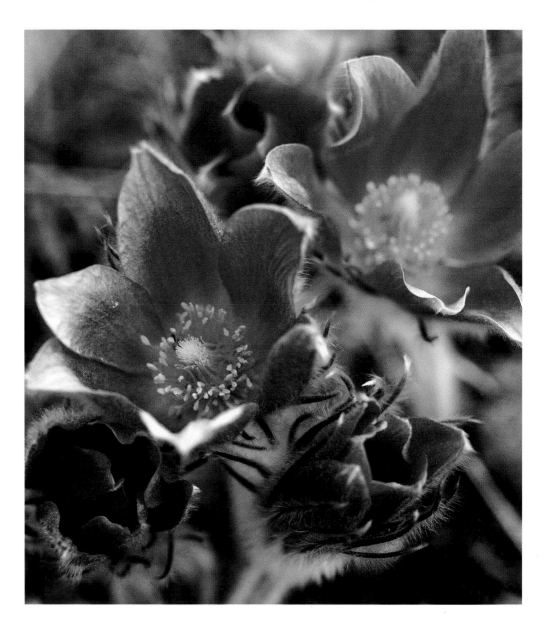

Preening Muskrat. *This scene was recorded from a floating blind near the muskrat's lodge. First morning light, before the wind rises, is the best time to capture reflections. Light cloud cover softened the light and provided good illumination of the shadow areas of the muskrat's fur. Dark animals like muskrats, black bears, crows, and gorillas are best photographed on cloudy days. Canon T90, 500 mm L Canon lens, 25 mm extension tube, Kodachrome 64, 1/125 second at f/4.5.*

Mink Shaking Water from Its Fur. *Anticipating this behavior, common with any fur-bearing animal once it emerges form the water, I had all camera settings prepared in advance and recorded this fleeting moment with help of a high speed motor drive. Back-lighting and a shaded background dramatized the flying droplets. The animal was shot under controlled conditions at a game farm. Canon EOS A2, 400 mm L Canon lens, 1.4X tele-converter, Fujichrome Sensia 100, 1/500 second at f/4.*

direction of the light because this can be changed by adjustment of the camera position. What I try to evaluate is the quality of the light. On clear days, it is hard (casting sharp shadows) and generates more contrast in the subject than the film usually can record. On cloudy days, it is soft (casting faint shadows, or none) and illuminates all parts of the subject evenly to deliver rich colors to the film. Overcast skies are generally a close-up photographer's best friend. Occasionally you will come upon a shaft of sunshine that spotlights a subject dramatically or a shower of backlight that

transforms an otherwise ordinary subject (usually a translucent one). These discoveries are serendipitous and often ephemeral, requiring quick work to catch their passing magic. You can count on cloudy days to provide plenty of subjects and lots of shooting time.

WET DREAMS

Water is the third element of the natural setting which I try to bring into my photographs. Dew, ice, frost, snow, and the endless plastic configurations of water in the liquid state, all add drama to nearly any subject or scene. Although the photograph fixes a moment in time, water ironically raises simultaneous issues of time past (it was raining or snowing, the animal was swimming) and time future (it will evaporate or melt, the animal will shake itself or shiver). Water adds tactile elements to the photograph's basic appeal to the sense of sight. The colors of foliage or flowers are richer when they are wet. Water works like a mirror to reflect elements in the picture and create added visual interest.

WORKING A THEME

It has long been a convention of artists to explore a theme. French impressionist painters popularized this practice in the last century—Monet with his haystacks, cathedrals, and water lilies; Degas with the ballet and horse races. By limiting the subject matter or constraining the

approach to composition, they achieved fresh insight and renewed appreciation of their art. You may also find it engaging to focus your efforts on a single subject, a certain type of lighting, or a confined range of magnification. Placing limitations on your photographic approach permits you to more easily compare and evaluate various aspects of technique, composition, theme, and artistic concept.

OFF-CENTER CENTERS-OF-INTEREST

Early in your photographic experience, you likely learned about the rule of thirds, a compositional technique for positioning the center-of-interest within the frame. Although this contrivance is often effective, it doesn't deal comprehensively with the issue of where to locate the center-of-interest (main subject).

In every situation, the placement of the main subject is dependant on its visual strength relative to all the other elements of the composition. Because the eye automatically gravitates to the center of the picture frame, the closer the main subject is to this position, the more visual strength it gains. However, if the main subject is inherently strong (brighter, larger, smaller, etc. than the other elements in the composition), placing it in the center creates a static composition. Sometimes this may be appropriate to the picture's theme, but a dynamic composition is usually more desirable. It results when the main

Quaking Aspen Trunks. *The reflective properties of these trunks scattered light in all directions, producing a surreal, high key, studio-like effect. Photographing tree trunks has helped me to better analyze the effect of light on texture, evaluate depth-of-field, and experiment with rhythm as an organizing principle in picture design.*

Clockwise from top left (opposite).
Vine Maple Leaves on Vine Maple Trunks
Yellow Cedar Bark
White Birch Trunks
Bitter Cherry Trunks
Yellow Cedar Trunks
Baton Rouge Lichen on Baldcypress Trunk

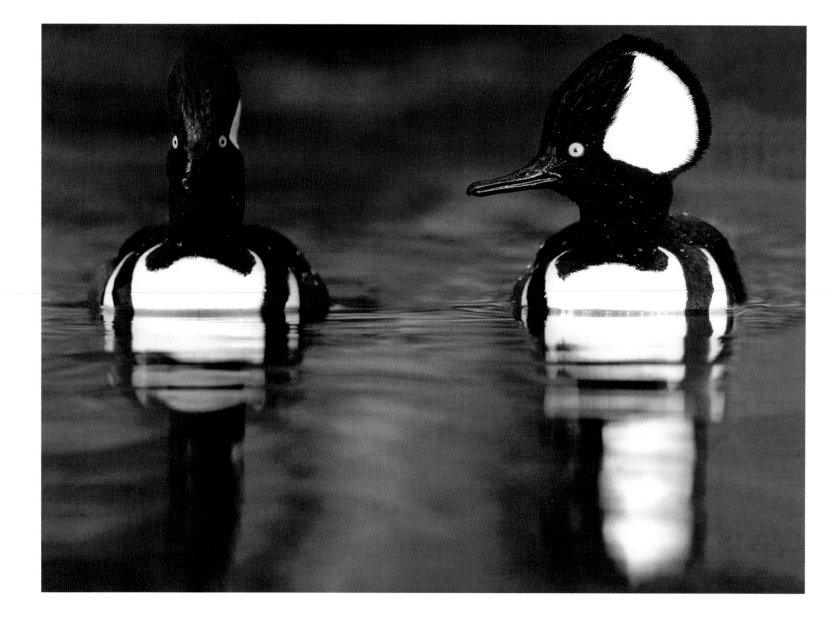

subject is placed away from the center. This causes the eye to shift repeatedly between the attraction of the subject and its natural resting place in the center of the frame. The stronger the main subject, the further from the center it can be placed without weakening the unity of the composition.

ARTISTIC ETHICS

How a photographer chooses to express his art is a personal matter. Nature photography has no relationship to sport or religion; it is not described by a set of rules; it is not a type of low-impact hunting; it is not even recording the visual facts of the environment. It is simply a way of communicating *your* ideas about the natural world using photographic methods.

Arranging Subjects in the Field

Everything from removing an unsightly stem in a wildflower portrait to creating an original still-life composition from components you gathered in the wild, perhaps over the course of several years, falls into the category of arranging nature. Should you do it? From the standpoint of art, it's not important how the photograph came to be, only how compelling it is to the viewer. If you remove a twig that spoils a wildflower composition, no one is going to know or care. The photograph may misrepresent what you found at your feet, but it doesn't misrepresent nature.

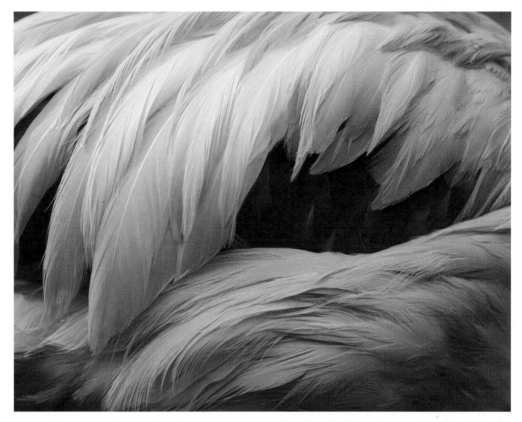

Hooded Merganser Drakes. *This image is a seamless montage of two views of a single merganser photographed from a mobile floating blind on the British Columbia coast during the winter. The two photographs, taken only seconds apart, were scanned on a desktop computer and then combined using Adobe Photoshop software. A composition is normally ineffectual when it has two equally strong centers-of-interest, but in this case the striking uniformity of the two drakes invites back and forth comparison, which generates a singular conceptual theme. Canon T90, 500 mm L Canon lens,1.4X teleconverter, Kodachrome 64, 1/180 second at maximum aperture.*

Preening Caribbean Greater Flamingo. *This study of avian textures was made at the Albuquerque Zoo. Canon EOS A2, 400 mm L Canon lens, 1.4X teleconverter, Fujichrome Sensia, 1/125 second at f/5.6 (effective aperture of f/8).*

At the other end of the spectrum, how should one judge a wholesale fabrication of natural phenomena—a frog in an aquarium, or an arrangement of seashells decorated with a sprinkling of wildflower petals on a patch of sand poured from a bag? If the viewer is impressed by the photograph; if he comes to think that amphibians are precious or he longs to visit the Florida Keys or he simply enjoys the visual experience, then the images have value.

Any photograph is but a sheet of paper or plastic spread with inks or dyes that represent a photographer's point of view. An uninspiring photograph of an eagle taken in the wild is simply a boring photograph. It has less value than an exciting photograph of an eagle taken in a zoo or even an exciting photograph of a chicken, made up to look like an eagle, taken in a studio.

Outdoors with Restraint

Just because you can manufacture nature in a studio doesn't mean you should. For most people it's more enjoyable and almost always

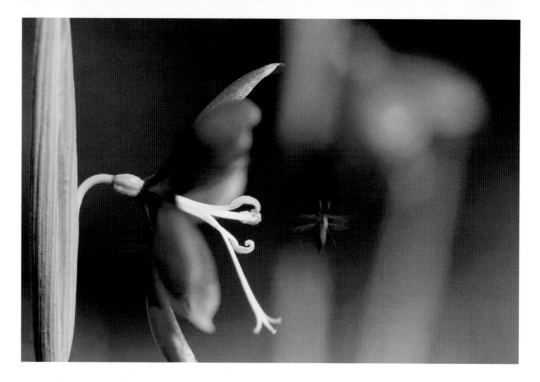

Grasshopper on Penstemon. *The compositional approach to this picture was similar to that for the Indian blanket meadow (right). A longer lens was needed to avoid frightening the grasshopper. Canon EOS A2, 400 mm L Canon lens, 1.4X teleconverter, 25 mm extension tube, Fujichrome Velvia (rated at ISO 40), 1/180 second at f/4 (effective aperture of f/5.6).*

Satin Flower and Gnat. *Unless you choose to work with captured bugs in the confines of a studio or take all of the paraphernalia of the studio into the wilds, capturing insects in flight is a hit-or-miss undertaking. But when it does happen, the spontaneity, delicate natural lighting, and authentic color usually succeed in producing superior images to those derived from studio procedures. Canon T90, 300 mm L Canon lens, extension bellows, Kodachrome 64, 1/125 second at f/5.6.*

Indian Blanket Meadow. *Natural light and a large aperture for minimum depth-of-field created this dreamlike effect. Choice of camera angle was key to achieving the arrangement of out-of-focus color—the basis of the picture's success. Canon EOS A2, 100-300 mm L Canon lens, 25 mm extension tube, Fujichrome Velvia (rated at ISO 40), 1/250 second at f/4.5.*

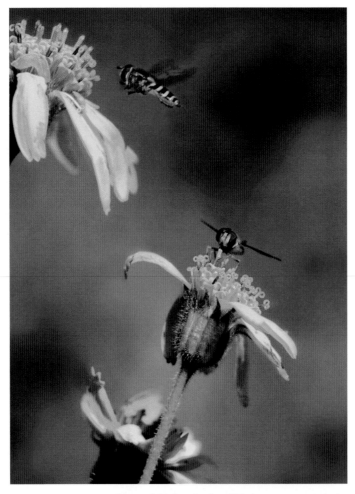

Bees at Alpine Arnica. *This image was created from two frames shot seconds apart. The similarity of the backgrounds and lighting made it an easy matter to copy and paste one of the bees into the sister image using Adobe Photoshop software on my desktop computer.*

more efficient to work outdoors. Here you needn't worry if the photograph conveys a convincing impression of the wild; this quality usually comes with the territory.

Just because you can rearrange subjects in the field doesn't mean you should. The more you change what you find, the more you risk losing the essential qualities of the scene that drew your attention in the first place. When I rearrange subjects in the field, I do so in order to strengthen what I initially found intriguing. Re-creating nature's random beauty is a tricky exercise and it is best conducted with restraint. Most such photographs are intended to represent the natural world in a realistic fashion, but obviously they are *not* the natural world. To be successful, they must earn and sustain the viewer's willing disbelief of this fact regardless of where and how they were made.

RECOMPOSING ON THE COMPUTER

When a painter manipulates and finally presents paint on canvas, it doesn't matter whether he used a brush, a palette knife, or his fingers; the result is still a painting. If a photographer records and manipulates light energy on film, paper, T-shirts, or computer monitors, it doesn't matter if the image was generated by a camera, an enlarger, or a computer; the result is a photograph.

Digital imaging has made photography as responsive for the practitioner as any other

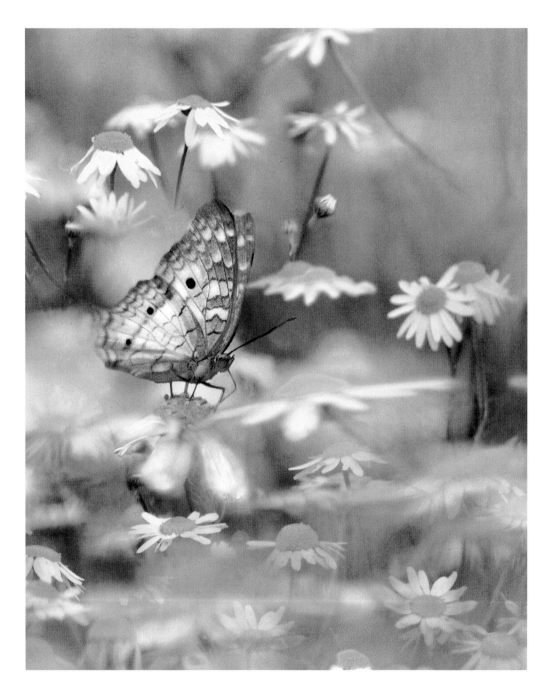

White Peacock Butterfly in Daisy Patch. *I copied the butterfly along with its daisy host from one image and then pasted it into the daisy meadow. Then I moved and enlarged a few of the daisies to improve the composition. I shifted the color balance toward yellow and increased the saturation. The result is a seamless photographic rendering of a natural event that, like the grasshopper photograph on page 86, might just as easily have been accomplished in the camera alone.*

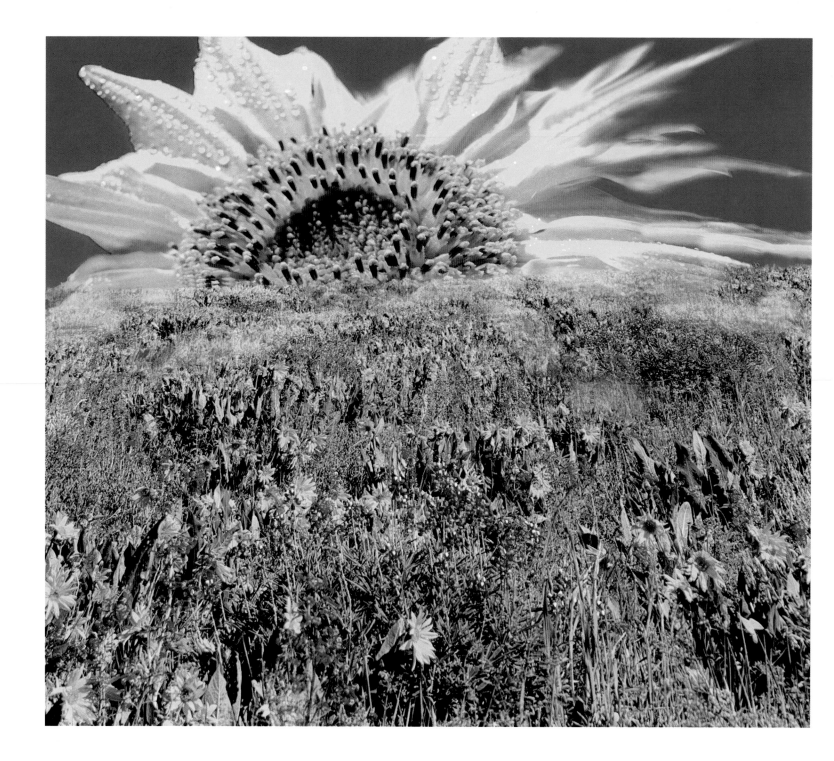

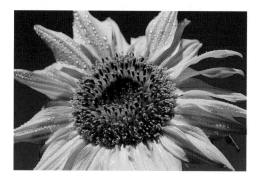

Sunflower Rising. *Digital imaging has many applications. In this example, I used it to create a surrealistic image in which I wanted to express the pleasant, dreamy sensations that can be drawn from a meadow flooded with sunshine and strewn with wildflowers. The picture components, shown above, were scanned on a Polaroid Sprintscan 35 Plus. They were modified extensively in Adobe Photoshop 4.0 in the treatment of scale, color balance, perspective, sharpness, and seamless integration. Rays of sunshine, emanating from the giant sunflower, were painted into the landscape using Photoshop's painting tools.*

method of creating visual art. It has relieved the lingering charge that photography is machine art. In the process, it has placed new demands on the technical skills and aesthetic perceptions of the artist/photographer.

I make use of digital imaging frequently. I use the camera to gather visual ideas from nature and the computer to shape them into a dramatic form. Although more challenging than working with a camera alone, the process is also more enjoyable. If you haven't yet embraced digital imaging, sources listed in the appendix will help you get started in this new dimension of the photographer's art.

To do professional quality work, you may have your transparencies scanned at nominal cost on Kodak CD ROM media or you may do your own scans on a desktop scanner, which allows more spontaneity in creating images. I have used both Nikon and Polaroid desktop scanners extensively; the Polaroid scanners are far superior in image quality and ease of use. Costs are about the same.

Due to the large size of the photo files (millions of pixels), computer essentials include a high speed central processing unit and abundant RAM. Fortunately, computer prices become more affordable every day. There is a variety of inexpensive color printers now on the market that are suitable for making exhibition quality prints from computer files. My preference is the Epson Stylus series, which produces brilliant, near liquid color

using 1440 X 720 dots per inch resolution or six color inking for continuous tone. Reproduction quality is equal to or better than what you see printed here.

The most popular photo editing software, offering more features than you could ever use, is Adobe Photoshop. You needn't purchase the full version initially. Photoshop LE (limited edition) and Photoshop Deluxe are excellent starter programs with extensive applications. Many scanners are sold with a version of Photoshop included.

INSPIRING SUBJECTS

Keep in mind the reasons you started carrying your camera and tripod into the woods in the first place—enjoyment of flowers, trees, birds, and butterflies and the desire to express your impressions of this beauty. Try to sustain this light and generous feeling whenever you are working. If you have any doubts about whether you are impacting negatively on the natural setting, put yourself in the place of the subject. Would you prefer to be left alone by this photographer? If your subject is not sharing your sense of joy in the creative process, consider moving on to something else. There are plenty of subjects, both animal and vegetable, that you can photograph and that will be happy to share the wilderness with you.

Subjects in the Wild

Subjects in the Wild

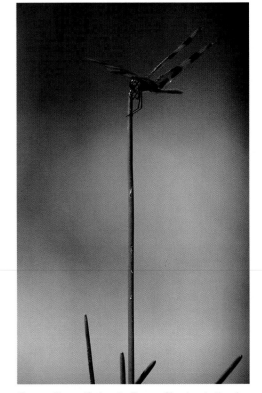

Dragonfly on Bulrush. *Dragonflies hunt other insects, capturing them on the wing within their cagelike legs. Their eyesight is keen and they must be approached cautiously. This solitary bulrush was a popular resting area and I aimed the camera at its tip and waited motionlessly. Canon EOS A2, 500 mm L Canon lens, 25 mm extension tube, Fujichrome 100, 1/500 second at f/4.5.*

Skipper Butterfly on Bird's Foot Trefoil. *Canon T90, 300 mm L Canon lens, extension bellows, Fujichrome 50, 1/90 second at f/4.*

MANY SMALL CREATURES do not look upon humans as a direct threat to their well-being, as might an ostrich or deer. They are nevertheless vulnerable to predation by many other animals and so have developed methods to avoid or repel danger which are usually of concern to the photographer. In order to work in the close-up range with small wild subjects, consideration of the animal's habits and physiology is required. Much can be learned from observation in the field as well as from reference literature.

Of the more than one million known animal species, 98% are cold-blooded and their behavior is largely governed by the temperature of their surroundings. A butterfly opens its wings in the morning to catch the sun's early rays. A desert lizard seeks the shade at midday. All cold-blooded creatures become less active in cool temperatures, a factor on which the nature photographer often bases his approach.

A common method for photographing insects, reptiles, and amphibians is to cool them down so that they are less active before and during the shooting session. This is

done by capturing the subject, placing it in a refrigerator for a short time before transferring it to a photogenic setting. Such practice seldom harms the animal provided the creature is handled gently, cooled gradually, and returned to its home as soon as possible. Naturally most animals object to the procedure (until they are cooled off) and for this reason you may prefer other photographic approaches. Most of those described below allow you to work in the field amidst nature, the essential joy of nature photography for most people.

SPIDERS AND INSECTS

These small animals exist in a dazzling array of shapes and sizes. As in photographing other types of wildlife, a knowledge of their habits is extremely helpful. Successful photography outdoors requires that all preparations—setting up the camera, adjusting controls, framing, and focusing—be completed before dealing with the animal. Images made at magnifications greater than life-size are most easily done using electronic flash and/or a focusing rail for precise positioning of the camera.

Many flowers are pollinated by insects, spiders, or even birds. To induce animals to undertake this task, flowers are attractively shaped, colored, and stocked with free food (nectar). As such, they make beautiful and productive locations for photography.

Crab Spider on Milfoil. The camouflaged crab spider catches its prey by remaining motionless, making it easy to approach. Canon T90, 100 mm Canon macro lens, extension bellows, Kodachrome 64 (rated at ISO 80), 1/125 second at f/5.6.

Honey Bee on Sea Blush. The painful sting of the honey bee intimidates other animals and makes it bold. It is possible to approach feeding honey bees as close as you want provided you don't act aggressively, even if one should land on you. Canon T90, 100 mm Canon macro lens, 25 mm extension tube, Kodachrome 64 (rated at ISO 80),1/125 second at f/64.

Stick Bug. I relocated this docile creature to a twig that was backlit against a shaded background. After shooting I put the subject back where I had found it (in a pot of geraniums). Canon EOS A2, 70-200 L Canon lens, +2 supplementary lens, Ektachrome EPP 100, 1/125 second at f/4.

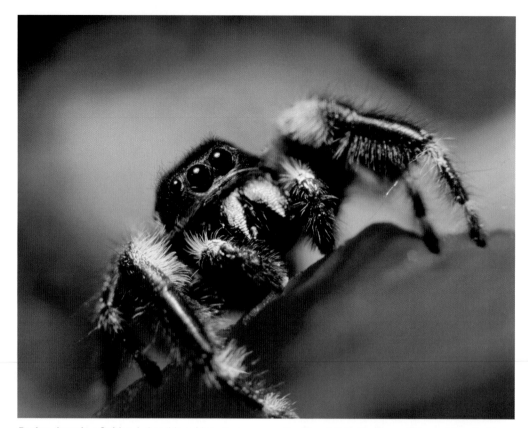

Daring Jumping Spider. I shot this spider using a handheld macro-bracket flash set-up. This kind of lighting is undramatic but its intensity allows you to attain good depth-of-field and its brief duration eliminates the adverse effect of camera shake, producing professional results from grab-shooting forays in the field. Canon EOS A2, 50 mm lens, extension bellows, Canon Speedlite 380 EX, Lumiquest Pocket Bouncer, Fujichrome Astia, 1/125 second at f/11.

Swallow-tail Butterfly on Clover. A handheld full-flash set-up (no ambient light registered on the film) was used to record this large butterfly. Even with the bellows fully collapsed, reproduction was too great to capture the entire creature. I approached this hungry, surprisingly preoccupied specimen slowly from the front and managed to bring the lens within a few inches of its proboscis before shooting. Canon F1, 100 mm Canon macro lens, bellows, two small manual flash units on a macro bracket, Kodachrome 25, 1/60 second at f/11.

On locating an active flower patch, you may pursue several approaches. For butterflies, the most elusive of the six-legged subjects, set up a 400 to 500 mm telephoto lens adapted for close-ups on a tripod at bloom height. This camera position produces an intimate, revealing view of the subject against a soft, passive background usually in harmony with the other picture elements. Try to locate the camera so that two or three blooms are within focusing range. Aside from the degree of magnification, give attention to the nature of the foreground, background, and the lighting angle. Then take a comfortable seat on the ground behind the tripod, since even in a bustling location, worthwhile images require considerable patience. While waiting, you can swing the camera to and fro to practise framing and focusing on the selected targets.

Bees, wasps, beetles, and some flies will allow you to approach them nearly as close as you wish. For these creatures, I use extension tubes and a shorter lens (for higher magnification) and mount the camera on a monopod, its length adjusted to a couple of inches more than the height of the blooms. With focusing distance and exposure already set, I merely lean in toward the subject, eye to the viewfinder, and begin shooting when the scene pops into focus. The monopod produces satisfactory camera steadiness and nearly handheld flexibility at magnifications up to life-size when working in full sunlight with medium speed films.

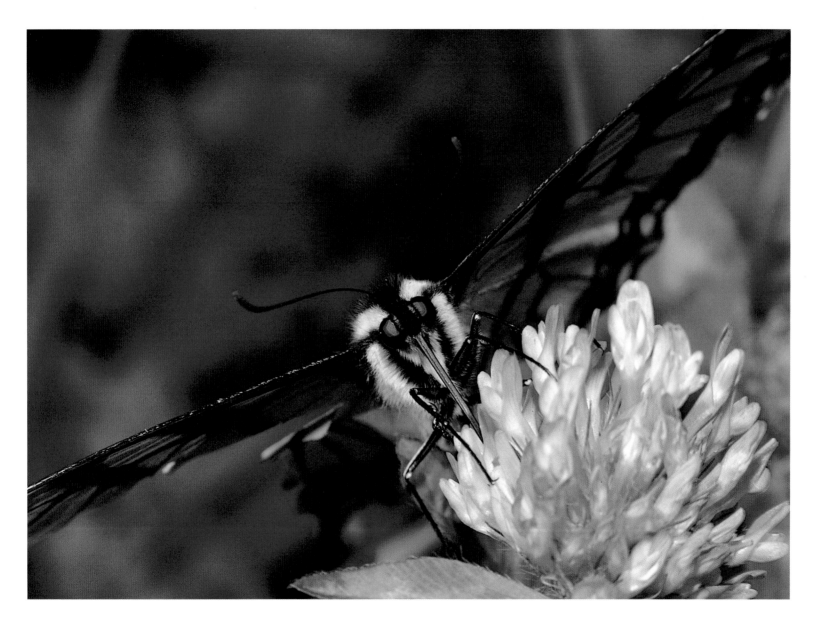

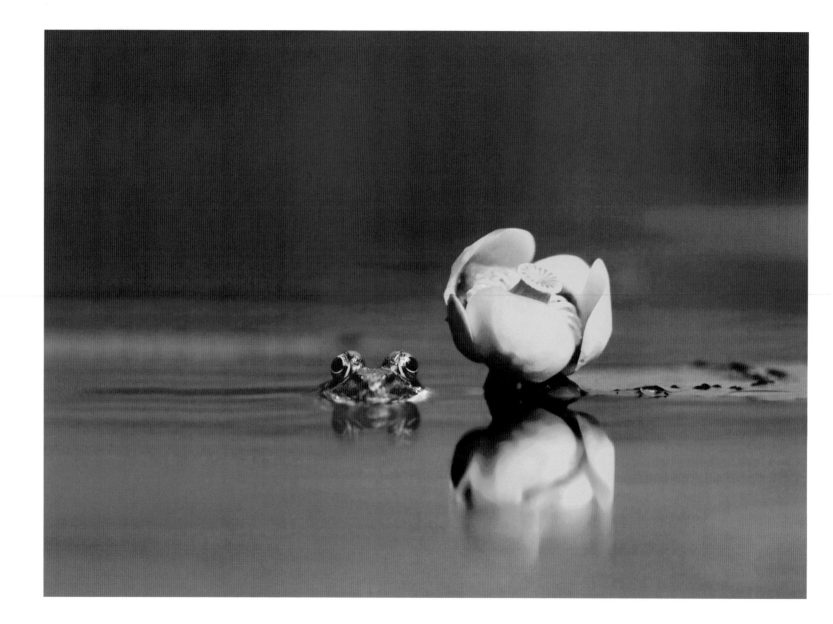

Spider portraits usually require the use of full electronic flash due to the high magnification (frequently exceeding life-size) needed to render the spider's eye panel in fine detail. As with other wildlife, the spider's eyes are the center-of-interest and the portrait will not be successful unless they appear sharp and bright. The high intensity of the flash solves both of these requirements efficiently, creating highlights in the spider's eyes while simultaneously effecting a stop-action exposure at a relatively small aperture for good depth-of-field.

I like to use a 100 mm macro lens with a 2X teleconveter, a lightweight, flexible combination producing up to 2X magnification while retaining all of the camera's automatic features except focusing. I use a standard, adjustable-head flash unit mounted in the camera's hotshoe. A Lumiquest Pocket Bouncer reflects and spreads the flash down onto the subject yielding much the same effect as full sunlight. Flash fall-off, resulting in a black background, is usually not a problem because the field-of-view is usually taken up by the surface the animal is resting on, which is close enough to receive adequate illumination. If you don't have a macro lens, stacked lenses work just as conveniently but offer little adjustment of image magnification. You can also use a bellows with a short-mount lens or a reversed normal or wide-angle lens—a set-up that provides a full range of magnification and allows easy shifting between horizontal and vertical formats.

Start by making an exposure at the lens' smallest aperture, checking for correct exposure confirmation in the viewfinder or on the back of the flash unit. If the diode does not light up, open the aperture one stop and try again. When using ISO 100 film, most standard flash units will begin giving exposure confirmation at about f/11 and larger apertures.

FROGS AND TOADS

Working with these animals is fun and often easy. With caution, you can usually draw within frame-filling, medium telephoto range. My favorite way of shooting frogs is to wear chest waders and move quietly through the shallows of a lake or pond near the shoreline with a camera and tripod in water up to waist-deep. Normally, frogs basking on the beach flee to deep water if frightened. However, with this appraoch, you block their line of flight and they tend to stay put, giving you a chance to set up the tripod and begin shooting. I place the camera as close to the water's surface as possible, even immersing the tripod head. A lens of 300 mm with a +1 or +2 supplementary close-up lens or a 50 mm extension tube or bellows provides good magnification and working distance.

SNAKES

Keep in mind that some species of snakes are

Leopard Frog and Yellow Pond Lily. *The pond lily was shot from a floating blind while I was photographing ducks. The leopard frog was recorded in its habitat from a tripod set up in waist-deep water. The two transparencies were scanned on a Polaroid desktop scanner and then combined to form a single image using Adobe Photoshop software. Similar backgrounds made the computer work easy. To capture the same image on a single frame of film would require a lot of luck unless you worked with a chilled frog in a studio setting.*

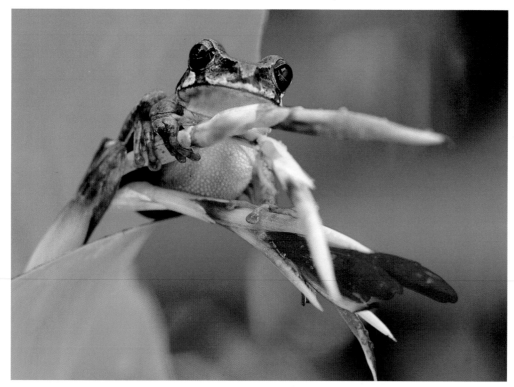

Treefrog on Heliconia Flower. *This Honduran frog was captured and cooled down gradually in a refrigerator (salad compartment). Once it grew lethargic, I took it outside and photographed it in a shady setting. Canon EOS A2, 70-200 mm L Canon lens, 25 mm extension tube, +2 close-up supplementary lens, Ektachrome EPP 100, 1/125 second at f/4.*

Treefrog in Rain Shower. *I came upon this frog clinging to a banana tree stem in the early morning. A recent rain shower gave me the idea of creating my own precipitation, which I called forth from an atomizer that I carry in my camera bag (usually used for misting wildflowers). By choosing a back-lit camera position, the spraying water glowed dramatically. I used a collapsible aluminum reflector (a car windshield sunshade) to direct fill-light onto the frog from the front. Canon EOS A2, 70-200 mm L Canon lens, +2 supplementary lens, Ektachrome EPP 100, 1/90 second at f/4.*

dangerous; if in doubt, keep your distance. Should you come upon a snake that is coiled up in a photogenic manner, work cautiously at a non-threatening distance with the longest telephoto lens you have. Usually, however, you will come upon an uncoiled serpent (a shape not easy to incorporate into a strong composition) that is heading for cover. If it is a small specimen, throw your shirt, jacket, or any handy fabric over the serpent. It will usually stop to hide under the cover you have supplied and coil up. This gives you an opportunity to prepare the camera and tripod for photography. Once you are ready, gently lift the cloth and begin shooting immediately. The snake normally will not stay put for long and a motor drive and auto-bracketing are good insurance for attaining a satisfactory portrait.

With a harmless snake, you may wish to place it on the low branch of a shrub for photography, a natural setting for many species that also provides a convenient working height as well as background/foreground design options. Be sure all camera preparations are carried out before relocating your subject.

TURTLES

Aquatic turtle species enjoy basking in the sun and you can readily find them at most healthy ponds and small marshes. At popular locations—sandbars, floating logs, rocks, river banks, and muskrat lodges—turtles may be piled

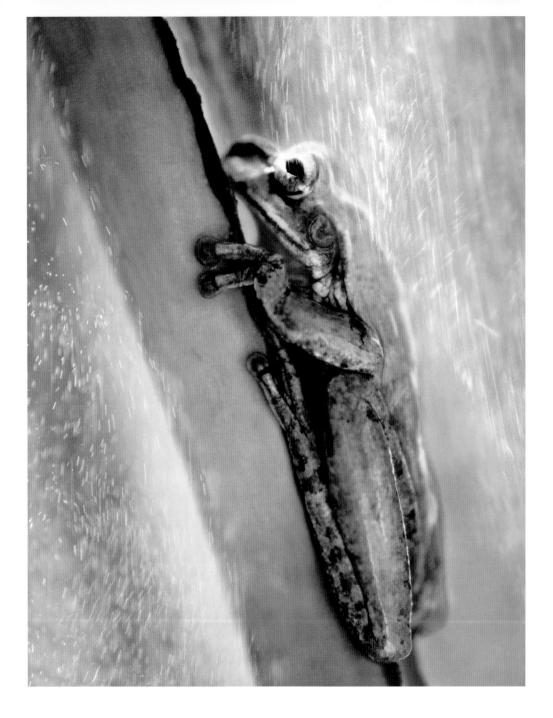

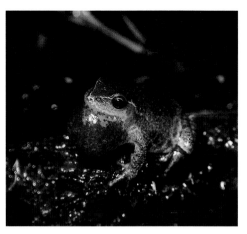

Spring Peeper. *This frog, about the size of a fingertip, was photographed after dark in a wooded swamp. (See the introduction.) I used a flashlight (attached to the camera/ bellows assembly) to locate the singing amphibian and provide light for bringing the handheld apparatus into focused position. Canon F1, 50 mm Canon lens, extension bellows, 2 small electronic flash units, Kodachrome 64 (rated at ISO 80), 1/60 second at f/16.*

Garter Snake. By taking an extreme close-up view, I was able to achieve a simple yet dramatic action shot of this serpent. The snake was cooled in the refrigerator and then held in front of the camera by my son. Canon F1, 50 mm Canon lens, extension bellows, 2 small flash units on a macro bracket, Kodachrome 64 (rated at ISO 80), 1/60 second at f/16.

Florida Softshell Turtle. I came upon this large turtle at Echo Pond in Everglades National Park where many reptiles are habituated to humans and easily approached. It stopped its progress toward the water and watched with great interest while I set up the tripod and camera and shot most of a roll of film. The near ground-level camera position dramatizes the turtle and places its head against out-of-focus background vegetation. Even though it was near midday, the white sand and bleached vegetation provided plenty of reflection into the shadow areas, keeping subject contrast within the range of the film. Canon T90, 300 mm L Canon lens, 25 mm extension tube, Fujichrome 50, 1/250 second at f/5.6.

Snapping Turtle. This turtle was discovered laying its eggs in the woods at Point Pelee, Ontario. The shaded forest and nearly imperceptible shuddering of the preoccupied reptile made it necessary to time my exposures to catch the animal when it was still. Like the photograph above, an eye-level camera position reduced background detail, simplifying the composition. Canon T90, 80-200 mm L Canon lens, Fujichrome 50, 1/8 second at f/5.6.

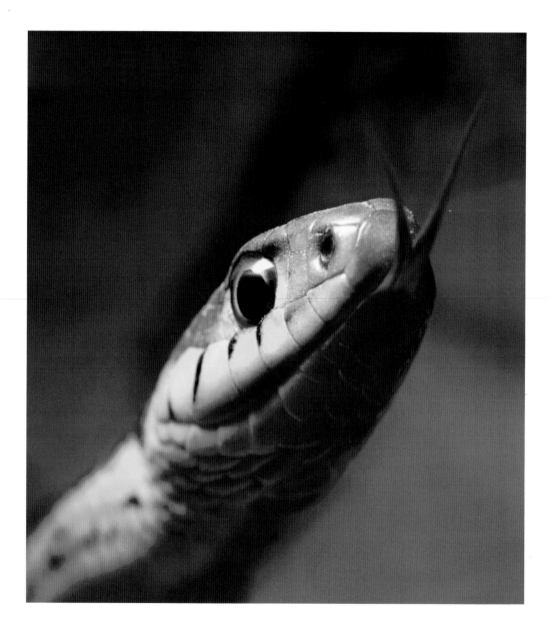

three high. Despite their lethargic appearance, they will disappear quickly into the water at the least sign of danger. You will have the most luck working in parks and refuges where the turtles are habituated to humans. Nevertheless, a cautious approach with a super-telephoto lens is usually necessary.

Specimens found on dry land are more easily photographed. If alarmed by a photographer, they either remain still, retracting into their shells for a while, or continue their way in a determined fashion. If necessary, you can hold the turtle in place until you are ready to shoot or move it to a photogenic setting nearby. For turtles crossing a highway, the latter procedure may save them from a premature demise.

HUMMINGBIRDS

It is difficult to photograph these tiny nectar-loving birds in a truly wild setting, especially if you are interested in flight shots. You can photograph them most easily by setting up hummingbird feeders and planting tubular flowers, like lupines, gilias, and penstemons, in your backyard. Locate your feeders and hummingbird garden in an area that receives good light in the early morning. Hummingbirds are most active at dawn and the hour after. Luckily this is the time when there is least likely to be wind.

To photograph a hummingbird in a natural setting, you must encourage it to shift from vis-

iting an artificial feeder to a patch of wildflowers. I do this by replacing the feeder with appropriate species of potted wildflowers just before a photographic session. The hummingbird will be confused at first, but most will quickly give the natural offering a try. To keep the bird coming back at regular intervals and encourage it to visit the blossoms in front of your lens, you can use an eyedropper to fill individual blossoms with a mixture of four parts water to one part sugar (the standard hummingbird mixture).

Lenses of 300 mm and longer, equipped with extension tubes for close focusing, provide

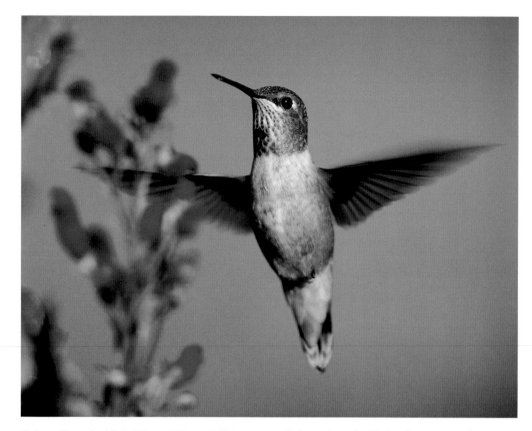

Rufous Hummingbird at Desert Figwort. *This hummingbird was conditioned to one of the feeders in my yard. In between its visits, I switched these flowers for the feeder. The hummingbird wasted little time giving the blooms a try. After each sip, it backed up and hovered in the same spot long enough for one photo, all the while keeping an eye on me. I took about four frames without changing focus! Canon EOS Elan II, 400 mm L Canon lens, 25 mm and 12 mm extension tubes, Ektachrome EPP 100, 1/2000 second at f/2.8.*

Rufous Hummingbird at Penstemon. *An approach similar to the opposite photo was used for this image. To give depth to the composition and simulate more natural conditions, I shot through an out-of-focus, foreground flower clump. Strongly front-lit by the sun, the scene shows evidence of fill-in flash in the tiny second highlight in the bird's eye. Canon EOS Elan II, 400 mm L Canon lens, Canon Speedlite 380 EX, 25 mm and 12 mm extension tubes, Ektachrome Lumiere (ISO 100), 1/1000 second at f/4.*

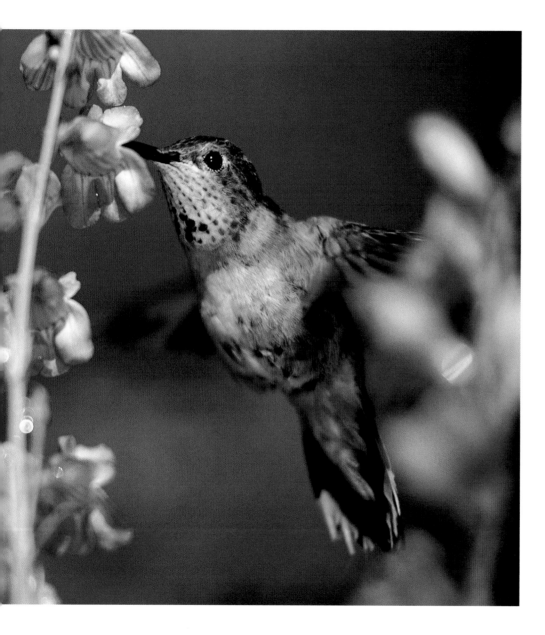

adequate magnification and ample working distance to prevent the hummingbird from becoming nervous. It isn't necessary to use a blind to conceal yourself, provided you keep your movement slow and deliberate.

The standard approach to hummingbird photography entails shooting the birds against a sheet of sky-colored bristol board using three or four synchronized full-flash units—one fill light on the camera, a second main light above and to one side of the camera, the third directed at the bristol board, and the optional fourth flash behind the bird to provide backlighting about the periphery of the bird. The speed of the flashes stops all of the hummingbird's movment (no ambient light registers on the film). If you like nature photographs that look like they were taken in a commercial studio, this works well.

When shooting under natural light, you need to use an aperture of f/4 or larger and a film of ISO 100 or higher. This enables exposures of 1/350 second or faster in sunny, early morning settings—adequate speed to show the wings as a prominent blur. At slower speeds the wings disappear, especially with smaller species. Front-lighting from an on-camera, fill-in flash that synchronises at high shutter speeds or from the sun is necessary to illuminate the male's colorful throat patch.

APPENDIX

Sources

Sources

SUPPLIERS OF SPECIALIZED EQUIPMENT

Adorama Camera, Inc., 42 West 18th St., New York, NY 10011, 1-800-223-2500. Call for a comprehensive catalogue. Source of Adorama portable fold-up reflectors.

B & H Photo-Video, 119 West 17th St., New York, NY 10011, 1-800-947-9970. The mail order company of choice for professional photographers. Call for a catalogue.

Leonard Lee Rue Enterprises, 138 Millbrook Road, Blairstown, NJ 07825, 1-908-362-5808. A variety of specialized outdoor/nature photography accessories, including close-up flash brackets, Kimac individual slide protectors, outdoor photography guides, field guides, and natural history references. Call or write for a catalogue.

Kirk Enterprises, Inc., 107 Lange Lane, Angola, IN 46703, 1-800-626-5074. Specialized camera accessories, including lens reversing rings, close-up flash brackets, ball heads, long lens auxilliary supports.

KEH Camera Brokers, 188 14th Street NW, Atlanta, GA 30318, 1-404-892-5522. A good source of inexpensive, used lenses for creating "stacked lens" set-ups.

NATURE AND CLOSE-UP PHOTOGRAPHY GUIDES

The Adventure of Nature Photography, Tim Fitzharris, Hurtig Publishers Ltd., Edmonton, Alberta, 1983.

Art of Photographing Nature, Art Wolfe and Martha Hill, Crown Publishing Group, New York, 1993.

Beyond the Basics, George Lepp, Lepp and Associates, Los Osos, CA, 1993.

Canon Workshop Series: Close-up & Macro Photography, Jack K. Clark, Canon U.S.A. Inc., Lake Success, NY, 1996.

Designing Nature Photographs, Joe McDonald, Amphoto, New York: 1994. (For close-ups in studio settings.)

The Complete Guide to Wildlife Photography, Joe McDonald, Amphoto, New York, 1992.

How To Photograph Insects & Spiders, Larry West with Julie Ridl, Stackpole Books, Harrisburg, PA, 1994. (For close-ups outdoors.)

Hummingbirds of North America: Attracting, Feeding and Photographing, Dan True, University of New Mexico Press, Albuquerque, 1993.

John Shaw's Closeups in Nature, John Shaw, Amphoto, New York, 1987.

Nature Photography Hotspots, Tim Fitzharris, Firefly Books, Willowdale, Ontario, 1997.

Nature Photography: National Audubon Society Guide, Tim Fitzharris, Firefly Books, Willowdale, Ontario, 1996.

Photography and the Art of Seeing, Freeman Patterson, Key Porter Books, Toronto, Ontario, 1995.

Wild Bird Photography: National Audubon Society Guide, Tim Fitzharris, Firefly Books, Willowdale, Ontario, 1996.

NATURE PHOTOGRAPHY PERIODICALS

Nature's Best Photography Magazine, P.O. Box 10070, McLean, VA 22102.

Nature Photographer, P.O. Box 2037, West Palm Beach, FL 33402. Nature photography for purists.

Outdoor Photographer, 12121 Wilshire Blvd., Suite 1220, Los Angeles, CA 90025-1175.

Outdoor & Travel Photography, 1115 Broadway, New York, NY 10010.

Popular Photography, 1633 Broadway, New York, NY 10019. Best source for mail order company listings.

NATURE AND TRAVEL PHOTOGRAPHY NEWSLETTERS

Photograph America Newsletter, 1333 Monte Maria Avenue, Novato, CA 94947 (1-415-898-3736). An excellent guide to nature photography spots in North America.

Photo Traveler, P.O. Box 39912, Los Angeles, CA 90039 (1-800-417-4680). As above.

DIGITAL IMAGING

PC Photo, 12121 Wilshire Blvd., Suite 1220, Los Angeles, CA 90025-1175. Bi-monthly periodical on digital imaging for photographers.

Virtual WIlderness: The Nature Photographer's Guide to Computer Imaging, Tim Fitzharris, Amphoto, New York, 1998.

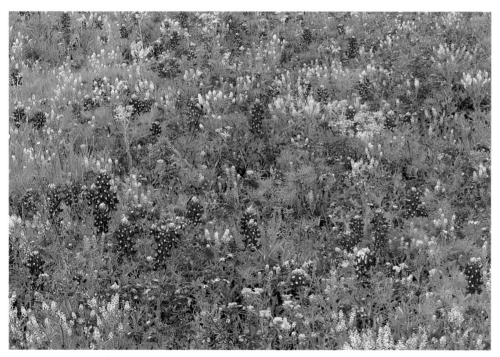

Texas Hill Country in April

PRODUCED BY TERRAPIN BOOKS
Santa Fe, New Mexico